ANGELA F

ART WITH MARKERS

A step-by-step guide to creating vivid landscapes and cityscapes with acrylic pens

CHRONICLE BOOKS

SAN FRANCISCO

First published in the United States of
America in 2025 by Chronicle Books LLC

First published in Great Britain in 2024
by ILEX, an imprint of Octopus
Publishing Group Ltd
Carmelite House
50 Victoria Embankment
London EC4Y 0DZ
www.octopusbooks.co.uk

An Hachette UK Company
www.hachette.co.uk

ISBN 978-1-7972-3318-5

Library of Congress Cataloging-in-
Publication Data available.

Printed and bound in China

10 9 8 7 6 5 4 3 2 1

Publisher: Alison Starling
Consultant Editorial Director:
Ellie Corbett
Managing Editor: Rachel Silverlight
Editorial Assistant: Ellen Sleath
Copyeditor: Alison Wormleighton
Art Director: Ben Gardiner
Design: Jack Storey
Senior Production Manager:
Katherine Hockley

Chronicle Books LLC
680 Second Street
San Francisco, CA 94107

CONTENTS

INTRODUCTION

You might have stumbled upon drawings made with Posca or Molotow acrylic paint markers online and thought it would be fun to try them out for yourself; at least, that's how I got interested in these markers. Despite my initial excitement, I found that they didn't yield the desired results on my mixed-media sketchbook. Consequently, I stowed them away for months.

In autumn 2018, I received blank coated cardstock paper unexpectedly, sparking the idea to give my Posca markers another try. Testing them on this paper, I was surprised to find they were a perfect match, instantly making the drawing experience more enjoyable. Since then, I've exclusively worked with these markers, expanding my collection, experimenting with different brands and uncovering new techniques along the way.

Discovering the right medium was transformative. Creating over 100 illustrations based on my travels solidified paint markers as my all-time favorite art medium. However, delving into a niche art medium comes with its challenges. There's a prevalent misconception that markers are limited to simple graphics, which I aim to disprove through my artwork.

In this book, not only will I comprehensively cover the basics of using acrylic paint markers, but I will also introduce several useful drawing techniques as well as basic color theory before delving into simple exercises. These exercises include drawing simplified flowers and trees, providing an opportunity for you to apply the knowledge and skills introduced. Moving on, I will explain how to create a good composition and build an atmosphere. Following this, there will be 22 step-by-step projects, progressively increasing in complexity. The aim is to help you explore the wonderfully versatile medium of paint markers and discover the joy of creating art with them.

THE BASICS

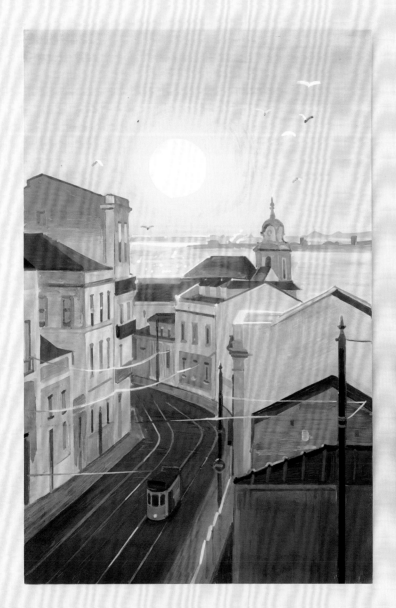

MARKER BASICS

Welcome to the world of paint markers! Many brands offer water-based acrylic paint markers, ideal for creating opaque and blendable drawings. In my experience, Posca and Molotow markers consistently outperform others in terms of quality and reliability. For beginners, I recommend starting with a basic set of eight or sixteen markers from either brand, along with an eight-marker pastel set, all in medium tips. You can supplement these with a few fine-tip and extra-fine-tip markers in the colors you frequently use. Even if you're using different brands, you can still match the colors mentioned in this book based on their hue, saturation and lightness.

POSCA MARKERS

Known for their high durability and user-friendly nature, Posca markers are my preferred choice for paint markers. While Posca markers may have different names in different countries, their product code remains consistent internationally.

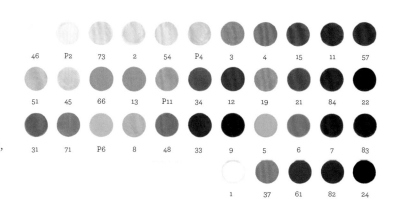

Recommended Posca tip sizes

Posca offers many tip sizes, but these are the tips I recommend:

1M EXTRA-FINE TIP 0.7–1mm:
 For detail and adding highlights

3M FINE TIP 0.9–1.3mm:
 For outlines or defining edges

5M MEDIUM TIP 1.8–2.5mm:
 For filling in shapes

7M BROAD BULLET TIP 4.5–5.5mm:
 For blending gradients

8K BROAD CHISEL TIP 5.5–8mm:
 For filling in large shapes

MOLOTOW MARKERS

Molotow offers subtle colors that are well suited for realistic and less saturated scenes. Typical sizes for Molotow One4all markers are 1.5mm, 2mm, and 4mm. Throughout this book, Molotow colors are italicized.

Recommended Molotow colors

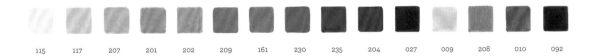

| 115 | 117 | 207 | 201 | 202 | 209 | 161 | 230 | 235 | 204 | 027 | 009 | 208 | 010 | 092 |

The Molotow One4all 127HS Pastel Set comes with ten colors in 2mm that are very versatile and useful. The colors include 115 *Vanilla pastel*, 009 *Sahara beige pastel*, 117 *Peach pastel*, 207 *Powder pastel*, 201 *Lilac pastel*, 020 *Lago blue pastel*, 202 *Ceramic light pastel*, 209 *Blue violet pastel*, 160 *Signal white*, and 180 *Signal black*.

Another Molotow set I would recommend is the 227HS Character Set, which comes with six warm colors: 117 *Peach pastel*, 207 *Powder pastel*, 009 *Sahara beige pastel*, 208 *Ochre brown light*, 010 *Lobster* and 092 *Hazelnut brown*. Additional colors I recommend are 161 *Shock blue middle*, 230 *Shock blue*, 235 *Turquoise*, 204 *True blue* and 027 *Petrol*.

MATERIALS

As paint markers are a relatively new art medium, there isn't yet a universally recognized set of art supplies specifically tailored to them. To assist newcomers embarking on their paint marker journey, here's a curated list of recommended materials to facilitate your exploration of this medium.

PAPER

Many beginners using paint markers struggle to find suitable paper. Through extensive testing, I've found that smooth paper works the best.

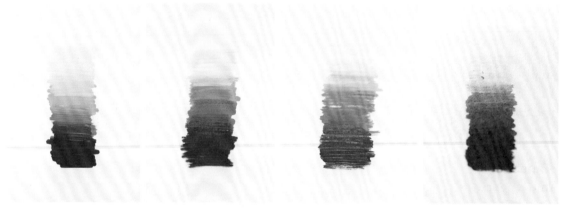

Coated smooth	Uncoated smooth	Uncoated medium tooth	Uncoated deep tooth
Smooth-coated paper is the ideal paper for blending and mixing colors. It allows the paint to sit without instant absorption, enabling seamless blending and mixing. It may require special ordering.	The next best option is uncoated but ultra-smooth paper, commonly found in sketchpads designed for markers. While blending won't be as easy, the smooth texture will create minimal pilling. (Pilling is when tiny balls of paper form on uncoated paper.)	This type of paper is suitable for other types of drawing but is not compatible with paint markers. Uncoated medium tooth paper isn't suitable for blending and tends to create pilling.	Watercolor paper, especially the cold-pressed variety, isn't suitable for blending and mixing paint markers. The paper can be damaged by the marker tips, causing distracting pilling.

OTHER MATERIALS

Here are some essential art supplies you may need when working with paint markers.

Replacement tips

Posca and Molotow offer replacement tips. While Posca replacements might not be widely available, they can be ordered from Japan. Additionally, some Molotow tips are compatible with Posca markers.

Refills

Both brands' markers are refillable. Molotow provides an extensive selection of paint refills.

Ruler

A ruler is helpful for drawing perspective.

HB pencil

An HB pencil is light enough to be covered by paint yet dark enough for the line art to remain visible while coloring.

Waterproof pen

A thin, waterproof pen is handy for detailed dark lettering or drawing very thin lines (such as telephone wires) that need precision.

4B Soft eraser

A soft eraser can protect the paper surface and allow for easier, more controlled erasing.

Masking washi tape

Japanese washi tape, known for being residue-free and easily removable, is ideal for masking out the drawing area. It can be removed later after a drawing is completed, leaving a clean edge.

GETTING STARTED

Now that we've covered technical information about these markers, you're almost ready to begin drawing. Before you start, let's go over a few preparation and cleaning steps that can enhance your drawing experience.

MARKER PREPARATION

One major advantage of acrylic paint markers over acrylic paint is their incredible convenience and ease of setup. Here are some tips for preparing these markers.

Shake before use

When using new markers or when the paint in the marker tip is depleted, gently shake the marker two or three times to mix the paint within the marker body.

Avoid vigorous shaking, however, as it can cause the paint to burst out from the tip when pressed down. (This is why, when travelling, it's preferable to store these markers in your carry-on bag rather than in a checked bag.)

Press lightly

Prepare your new marker on a spare sketchbook by gently pressing it down and pushing the tip inward to release the paint. If a marker has been inadvertently shaken during delivery or travel, it might dispense excess paint when being pressed down.

When you are attempting to extract more paint during the painting process, always test the tip on the spare sketchbook before applying it directly to your artwork.

CLEANING

Although paint marker tips are generally very durable and require little care, if they become tainted or dried out there are ways to clean them before considering replacement.

Clean any marker tip that has been covered with another color to restore the original color before using the marker again.

Keep a spare sketchbook handy to repeatedly wipe off the superficial residue until it's completely clear.

Molotow and poorly sealed Posca markers can easily dry out, requiring replacement or cleaning of the tips.

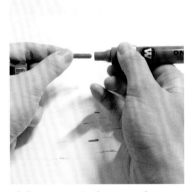

If the tip isn't damaged enough to be replaced, simply remove the dried tip from the marker for cleaning.

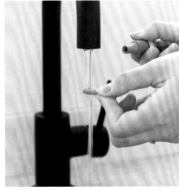

Thoroughly rinse the dried tip under a small flow of tap water to remove any dried paint residue.

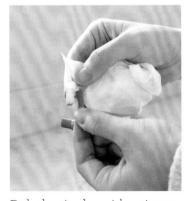

Dab the tip dry with a tissue before inserting it back into the marker for smoother paint flow.

MARKER CONTROL

Molotow and Posca marker tips, except for the brush tip, are firm, which ensures consistent, clear and precise lines. By adjusting the pressure applied, artists gain precise control over line weight variation. This flexibility makes these markers highly versatile, allowing for various applications within any artwork.

MOLOTOW MARKERS

Molotow One4all marker tips are firmer and release less paint compared with Posca markers, making it easier to achieve varying line weights by adjusting pressure. They come in six sizes, from 1mm to 15mm, but these are the two sizes I'd recommend you start with.

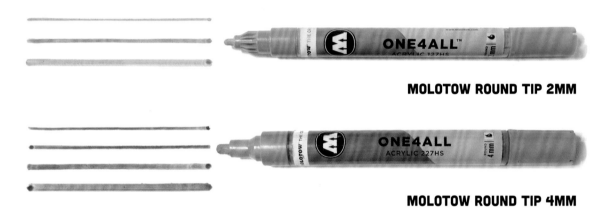

MOLOTOW ROUND TIP 2MM

MOLOTOW ROUND TIP 4MM

POSCA MARKERS

Posca marker tips have a slightly softer feel, are less likely to dry up and ensure a smoother paint flow. Each tip size allows for precise control, enabling a wide range of line weights. They come in nine tips with six shapes, but the following are the ones I'd suggest you begin with.

The 1MC extra-fine tip, already thin, may break or fade under light pressure. The 3M fine tip can reproduce the extra fine line with light pressure but transforms into a bold line with firm pressure. The 5M medium tip proves the most versatile, suitable for both thin outlines and thicker fills. The 7M broad bullet tip, softer than others, may require layering for opacity and can be challenging for thinner lines. The 8K broad chisel tip's edge achieves thin lines, while its flat side produces ultrathick lines, making it very versatile.

POSCA 1MC EXTRA-FINE TIP 0.7-1MM

POSCA 3M FINE TIP 0.9-1.3MM

POSCA 5M MEDIUM TIP 1.8-2.5MM

POSCA 7M BROAD BULLET TIP 4.5-5.5MM

POSCA 8K BROAD CHISEL TIP 5.5-8MM

CHOOSING COLORS

Understanding basic color theory, particularly in the context of paint marker colors, is incredibly helpful when choosing the color scheme for your artwork. I have included in this section a selection of color schemes to help you choose colors that will make the most of the markers' special characteristics.

COLOR WHEEL

A color wheel showcases primary, secondary and tertiary colors, showing their relationships to each other and aiding artists to understand harmonies and contrasts and to combine colors effectively. A basic color wheel shows just the hue of each color (without white or black added).

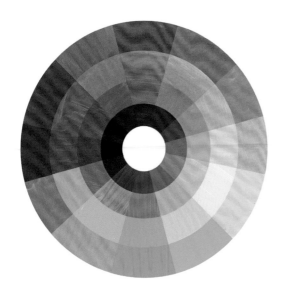

Primary colors
red, yellow, blue

Secondary colors
orange, green, violet

Tertiary colors
red-orange, yellow-orange, yellow-green, blue-green, blue-violet, red-violet

Warm colors
The "temperature" of a color refers to its "warmth" or "coolness." Warm colors include red, orange, yellow and their variations. Warm colors often evoke feelings of energy, passion, vibrancy, and cosiness.

Cool colors
Blues, greens, and purples are commonly known as cool colors. They tend to evoke feelings of calmness, tranquility and relaxation.

Analogous colors
These are any three hues that are adjacent to each other on the color wheel. They can create a particularly harmonious effect when used together.

Complementary colors
Two colors on opposite sides of the color wheel are complementary colors and will create the highest contrast when placed together. For instance, blue and orange are complementary colors.

POPULAR COLOR SCHEMES

A color scheme is a set of chosen colors that are harmonious and set the mood of an artwork. Here are some common Posca color palettes based on different times of the day.

Sunrise

The low angle of the sun paints the sky with warm colors like reds, oranges and yellows, accompanied by soft pastel hues of pink and lavender.

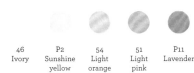

| 46 Ivory | P2 Sunshine yellow | 54 Light orange | 51 Light pink | P11 Lavender |

Sunset

Sunrise and sunset share similar colors, with sunset being slightly redder, due to pollutants and wind-borne particles.

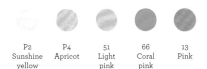

| P2 Sunshine yellow | P4 Apricot | 51 Light pink | 66 Coral pink | 13 Pink |

Midday sun

On clear sunny days the sky appears blue, and this blue tint is reflected in shadows. Under bright sunlight, objects' colors look richer.

| 1 White | 8 Light blue | 48 Sky blue | P6 Aqua green | 5 Light green |

Blue hour

Blue hour colors are the cool tones observed just before sunrise or after sunset, characterized by shades of blue, purple, and deep violet.

| 8 Light blue | 48 Sky blue | 34 Lilac | 31 Emerald green | 9 Navy blue |

Golden hour

Golden hour colors refer to the warm, soft hues seen shortly after sunrise or before sunset, characterized by shades of yellow, amber, orange, and pink.

| 54 Light orange | P4 Apricot | 3 Bright yellow | 21 Brown | 51 Light pink |

Night-time

After the evening blue hour, the sky darkens and objects are lit by moonlight or artificial light sources, appearing darker unless near a light.

| 3 Bright yellow | 84 Cacao brown | 48 Sky blue | 12 Violet | 9 Navy blue |

VALUE & CONTRAST

Considering just the hue of a color, the pure color, isn't enough. For any artist, comprehending value and contrast is basic – it allows for adding depth, guiding attention, evoking emotions and bringing artistic visions to life.

VALUE

Value refers to the lightness or darkness of a color. It helps to create contrast, form and depth in an artwork. Converting color swatches to grayscale helps assess a marker color's value. I've organized here my most used Posca and Molotow colors by hue and value for reference. (Posca colors are shown in roman type, and Molotow colors in italic.)

Orange, brown

| 54 Light orange | 117 *Peach pastel* | P4 Apricot | 3 Bright yellow | 4 Orange | 19 Ochre | 208 *Ochre brown light* | 010 *Lobster* | 21 Brown | 84 Cacao brown | 092 *Hazelnut brown* | 22 Dark brown |

Pink, beige, purple

| 51 Light pink | 45 Beige | 207 *Powder pastel* | 66 Coral pink | 13 Pink | P11 Lavender | 201 *Lilac pastel* | 209 *Blue violet pastel* | 34 Lilac | 12 Violet | 57 Raspberry | 043 *Violet dark* |

Yellow, green

| 46 Ivory | 115 *Vanilla pastel* | P2 Sunshine yellow | 73 Straw yellow | P6 Aqua green | 5 Light green | 72 Apple green | 6 Green | 31 Emerald green | 235 *Turquoise* | 7 Khaki green | 83 English green |

Blue

| 1+8 White + Light blue | 8 Light blue | 202 *Ceramic light pastel* | 48 Sky blue | 161 Shock blue middle | 71 Turquoise | 230 *Shock blue* | 204 *True blue* | 33 Blue | 10 Prussian blue | 027 *Petrol* | 9 Navy blue |

CONTRAST

This directs the viewer's attention. Strong contrasts can draw the eye to focal points or important elements within the artwork. Contrast can also evoke emotions and set the mood of an artwork. Below are some recommended Posca color pairings categorized by their contrast levels.

Low contrast

Suggesting distance or haze, this makes elements visually recede in landscapes. Low-contrast details won't be distracting. Colors with low contrast between them blend together harmoniously. Here are some low-contrast pairings:

51 45 8 P6 34 21

Medium contrast

Providing enough distinction for colors and objects to stand out without being overwhelming, medium contrast is the ideal balance to maintain across most of the painting. Examples of medium-contrast pairs:

P2 5 P11 34 31 9

High contrast

Here we have a double-edged sword. When used effectively, high contrast enhances focal points, making them striking. However, if used improperly, it can overwhelm and distract the viewer. High-contrast pairings include the following:

1 48 51 12 46 84

MIXING TECHNIQUES

When starting with paint markers, people often prefer to restrict themselves to a limited color range at first, but you can enhance your artwork by mixing existing markers for precise shades. Overlay two markers to lighten, darken or adjust the color temperature directly on your artwork. Posca marker tips are generally better for mixing than Molotow markers.

LIGHTEN

Add white to lighten a color—this is ideal for creating a faded distant background affected by the atmosphere.

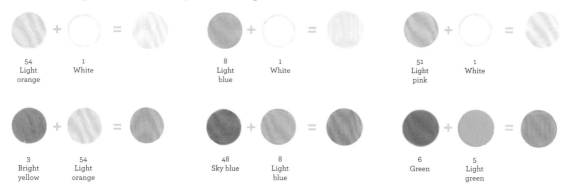

DARKEN

Darken a dark color by adding black for a desaturated (less intense) effect, which is useful for foreground elements. Or to maintain saturation (intensity), mix in a darker shade within the same hue.

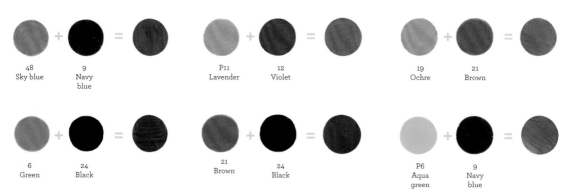

DESATURATE

To reduce a distracting effect caused by high saturation, add gray with a similar tonal value (lightness or darkness) to desaturate an existing color, toning down its intensity.

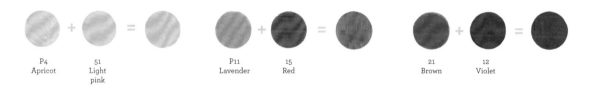

| 48 | 37 | | 34 | 61 | | 84 | 82 |
| Sky blue | Gray | | Lilac | Slate gray | | Cacao brown | Deep gray |

SHIFT TEMPERATURE

To adjust the temperature of an existing color, add a hue close to it on the color wheel. Mixing in such a color can cool down or warm up the original hue, as needed.

| P4 | 51 | | P11 | 15 | | 21 | 12 |
| Apricot | Light pink | | Lavender | Red | | Brown | Violet |

HOW TO MIX COLORS

Mixing colors on smooth paper while the paint is wet is crucial. You can control the outcome by adjusting the amount of the second color added. Additionally, reintroducing the initial color can help restore it to its original shade.

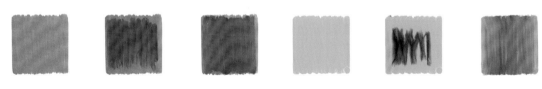

If the two colors are close in value, apply the first color, then, while it is still wet, lightly add the second, almost covering the first. Blend them gently using the first marker.

If one color is notably darker, it would dominate when fully applied. In that case, apply the lighter color first, then, while it is still wet, lightly add the darker color, and blend with the lighter marker.

DRAWING TECHNIQUES

Paint markers share similarities with other markers and mediums like gouache and acrylic paint. However, drawing with them involves unique techniques. By strategically using a variety of marker tips in the ways I show here, you can significantly enhance the creative possibilities of this versatile medium.

MAINTAINING SHARP EDGES

When defining specific objects in artwork, such as the edge of a roof, an ultra-sharp edge is crucial for the shape's clarity. Without it, the form may appear messy or lose its intended definition.

To achieve precision, begin by outlining the desired shape with an extra-fine-tip marker. When drawing straight lines, like the horizon, use a ruler, but be aware that paint overflow might seep beneath the ruler.

FILLING IN SHAPES

After outlining a shape with an extra-fine-tip marker, use a fine-tip marker in the same color to carefully fill in the area near the edge. This prevents accidental crossovers and upholds the precision of the edge.

If the shape is relatively large, proceed to fill the remaining space with a broad-tip marker, ensuring swift and even coverage.

SOFTENING EDGES

When dealing with shapes that need a softened edge, like a blurred shadow or the sea merging into the beach, it's important to be ready to soften the edge before the paint dries.

To achieve this effect, use a medium or broad-tip marker to blend the paint into the required shade while it remains wet.

OVERLAYING COLORS

When you're adding details or tweaking an existing color, it's entirely possible to overlay a new layer of opaque color on top, even if it's lighter than the original.

Wait until the initial layer is dry before applying the overlay for a well-defined shape – doing so before it has dried may cause uneven color or messy edges.

SMUDGING

Smudging is a quick technique to blend out newly added paint, creating effects like sun glow or light sparkles.

For a sparkle look, dot the center with a fine or extra-fine-tip marker, add more paint, then gently swipe your index finger in one direction. This technique is best for small areas; avoid using it on larger areas to prevent uneven blending and visible fingerprints.

BLENDING TECHNIQUES

While mastering art theories is important for creating any artwork, when you are using paint markers for realistic art, the crucial drawing technique of blending plays a significant role. Blending involves seamlessly transitioning among different shades of one hue or among analogous colors.

LINEAR GRADIENT

A linear gradient smoothly transitions colors in a straight line from one point to another. It's commonly applied to depict sky gradations, building surfaces and roads. Ideally, use markers with rounded, thicker tips – 4mm or above, like Posca's broad bullet-tip markers – for this technique.

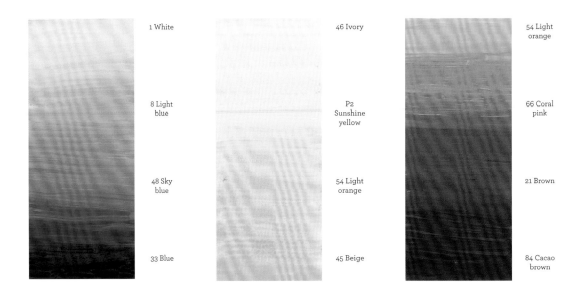

1 White

8 Light blue

48 Sky blue

33 Blue

46 Ivory

P2 Sunshine yellow

54 Light orange

45 Beige

54 Light orange

66 Coral pink

21 Brown

84 Cacao brown

RADIAL GRADIENT

A radial gradient is a type of gradient in which colors transition outward from a central point, creating a circular gradient pattern. It is useful for depicting the glow emitted from the sun, moon or other light sources. The thickness of the marker you need to use depends on the size of the glow. Leave the center as the white of the paper.

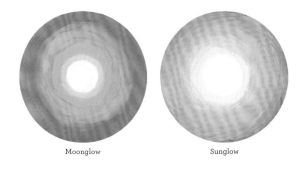

Moonglow

Sunglow

HOW TO CREATE GRADIENTS

To create smooth gradients, you need ultra-smooth paper, preferably coated paper. The coating will allow time for the paint to stay wet while you blend. The thicker the marker, the easier it is to blend colors.

Creating a linear gradient

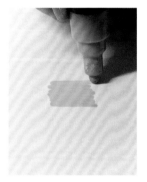 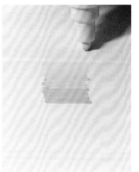 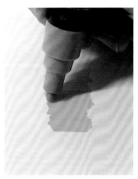

Use a medium-tip marker to draw in the first color.

From the edge of the first color, blend the second color outward.

Add a new region of wet paint using the first color on top of the dried area.

Start at a distance and blend an even darker color into the undried paint.

Creating a radial gradient

 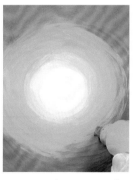

Circle the center with the lightest marker, leaving the center white.

Start blending in a second color that's slightly darker, creating a glow.

Circle the glow with a third color while the previous colors are still wet.

Start at a distance and blend the fourth color into the undried paint.

SUNFLOWER

Sunflowers radiate warmth with saturated tones and iconic, high-contrast colors, making them stand out among flowers. Symbolizing summer, they effortlessly find their way into illustrations, adding vibrancy to any artwork.

YOU WILL NEED

Markers

Extra-fine tip 0.7mm–1mm

Fine tip 0.9mm–1.3mm

Medium tip 1.8mm–2.5mm

HB pencil

Eraser

Colors (Posca colors in roman, Molotow in italic)

| Straw yellow | Bright yellow | Orange | Light green | Green | Sunshine yellow | Apricot | Brown |

| Cacao brown | Ochre | Apple green | White |

1.

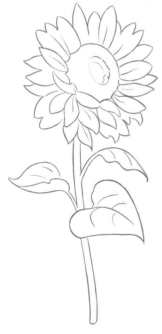

2.

1. Draw the sunflower's line art with an HB pencil, using a circle as a guide for drawing the outer petals in a round shape before erasing the circle. Create balance with the leaf shapes.

2. Lightly dab and lift the pencil work with an eraser, making it just visible. Trace the shapes using extra-fine- and fine-tip markers in Straw yellow, Bright yellow and Orange for the flower, and in Light green and Green for the leaves.

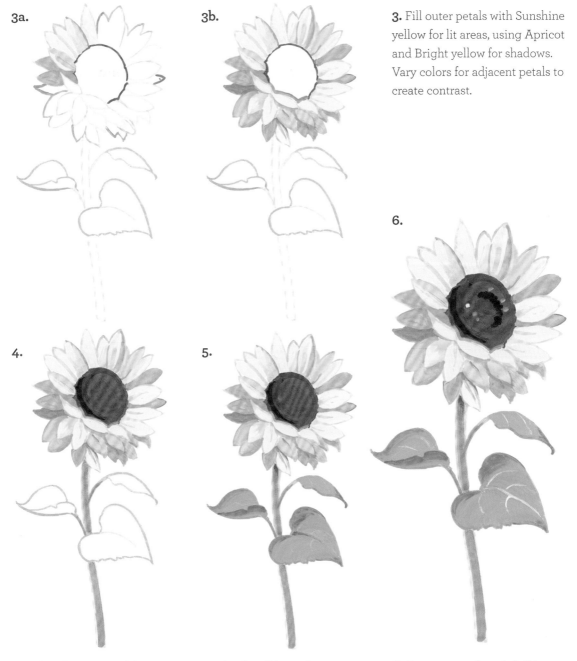

3a.

3b.

3. Fill outer petals with Sunshine yellow for lit areas, using Apricot and Bright yellow for shadows. Vary colors for adjacent petals to create contrast.

6.

4.

5.

4. Fill in the center of the sunflower with Orange, Brown and Cacao brown as the base color. While it dries, fill in the stem with a mix of Ochre and Apple green.

5. Blend well-lit Light green areas into Green for the shadowed regions on the leaves using both fine-tip and medium-tip markers.

6. Use an extra-fine-tip White marker mixed with a bit of Light green to add leaf veins. Now add details in the center of the flower using Cacao brown, Bright yellow and Sunshine yellow.

ROSES

Roses are iconic flowers known for their beauty. Pink roses symbolize admiration, gratitude and joy. While not as bold as iconic red, their soft pink hue carries a subtle charm that can be more pleasing to the eye.

YOU WILL NEED

Markers
Extra-fine tip 0.7mm–1mm
Fine tip 0.9mm–1.3mm
Medium tip 1.8mm–2.5mm

HB pencil
Eraser

Colors (Posca colors in roman, Molotow in italic)

Light pink · Light green · Apple green · Green · White · Pink · Fuchsia · Khaki green · Yellow

1.

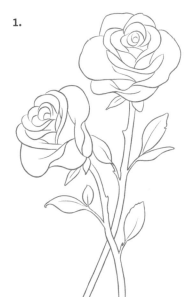

2.

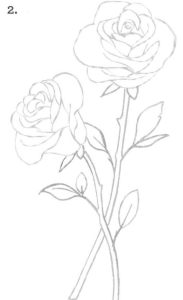

1. Sketch the roses with an HB pencil. Begin by blocking in the overall flower shape and stem length, ensuring balance. Add petals from large to small and incorporate simplified, uncluttered smaller leaves.

2. Clean up your sketch and dab the line art to lighten it. Trace the shapes using the extra-fine-tip marker in Light pink for the flower, and use fine-tip markers in Light green, Apple green and Green for the leaves.

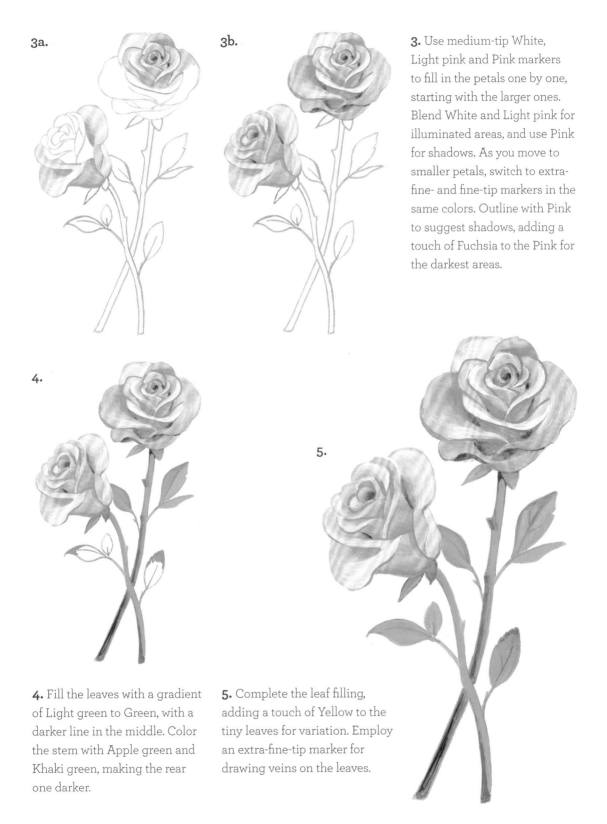

3a.

3b.

3. Use medium-tip White, Light pink and Pink markers to fill in the petals one by one, starting with the larger ones. Blend White and Light pink for illuminated areas, and use Pink for shadows. As you move to smaller petals, switch to extra-fine- and fine-tip markers in the same colors. Outline with Pink to suggest shadows, adding a touch of Fuchsia to the Pink for the darkest areas.

4.

5.

4. Fill the leaves with a gradient of Light green to Green, with a darker line in the middle. Color the stem with Apple green and Khaki green, making the rear one darker.

5. Complete the leaf filling, adding a touch of Yellow to the tiny leaves for variation. Employ an extra-fine-tip marker for drawing veins on the leaves.

BELLFLOWERS

Bellflowers, also known as campanula, come in a variety of colors. Purple bellflowers are known for their charming and distinctive bell-shaped blooms. The color of the flowers can range from a deep purple to a lighter lavender hue.

YOU WILL NEED

Markers
Extra-fine tip 0.7mm–1mm
Fine tip 0.9mm–1.3mm
Medium tip 1.8mm–2.5mm

HB pencil
Eraser

Colors (Posca colors in roman, Molotow in italic)

| Lavender | Violet | Apple green | Green | Light pink | Lilac | Sunshine yellow | White |

1.

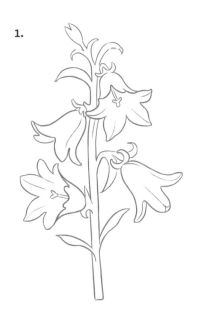

2.

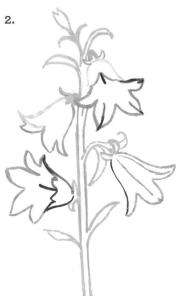

1. Sketch out your bellflowers with an HB pencil, starting with the flower petals. Bellflowers usually have a tubular shape that flares out at the open end. Next, sketch the stems and leaves.

2. Simplify the silhouette of each flower, then lighten the line art with an eraser. Trace over the line art using extra-fine- and fine-tip markers in Lavender and Violet for the flowers, and Apple green and Green for the stems and leaves.

3a.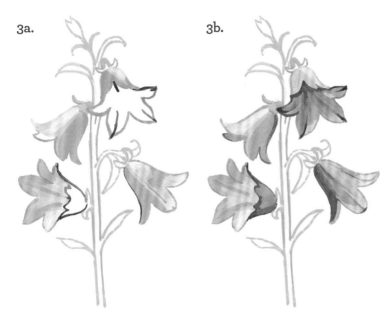

3b.

3. Start filling in the lighter areas of the purple flower petals with medium-tip Light pink and Lavender markers. Apply Light pink to the top-lit portions and areas where light is shining through.

Work on the shadowed areas by outlining the edges with a fine-tip Lilac marker, and immediately blend it out with a medium-tip Lavender marker. Utilize an extra-fine-tip Violet marker for the darkest details.

4. Fill in the warm tones of the stems and leaves using fine-tip Sunshine yellow and Apple green markers. Outline the darker edges with an extra-fine-tip Green marker.

5. Apply highlights to the flower petals and indicate the stigma with white tips using an extra-fine-tip White marker. Use an extra-fine-tip Violet marker for darker details.

4.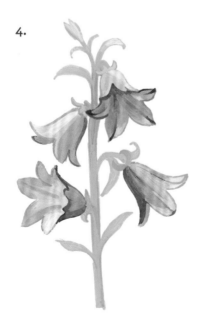

5.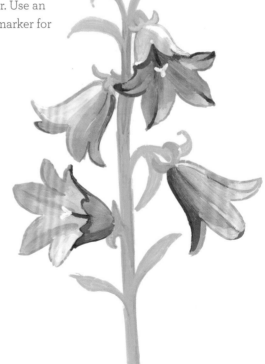

CHERRY BLOSSOMS

Cherry blossoms typically bloom in spring, gracing us with their presence for a short yet special period. Their soft pastel colors are mesmerizing on their own but become even more beautiful against the backdrop of a blue sky or greenery.

YOU WILL NEED

Markers

Extra-fine tip 0.7mm–1mm

Fine tip 0.9mm–1.3mm

Medium tip 1.8mm–2.5mm

HB pencil

Eraser

Colors (Posca colors in roman, Molotow in italic)

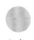

| Light pink | Apple green | Brown | White | Pink | Green | Cacao brown | Coral pink | Orange |

1.

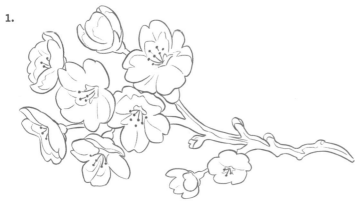

2.

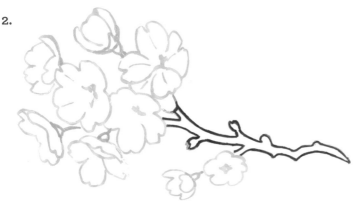

1. Cherry blossom petals have a cleft at the tip, making them look heart-shaped. They bloom in clusters, originating from the same bud. Draw the flowers individually at varying angles and let the branch curve slightly for a more natural appearance.

2. Make sure your line art is light but visible, then trace the petal shapes with an extra-fine-tip Light pink marker. Use a fine-tip Apple green marker for the sepals and stems, and an extra-fine-tip Brown marker for the branch.

3.

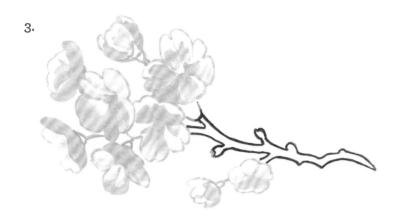

3. Fill each flower with medium-tip Light pink and White markers, with some petals in shadow. Use an extra-fine-tip Pink marker to darken the outline of the Light pink area and the center.

4. Fill the sepal and stem of each flower with a fine-tip Apple green marker. Outline it on the shadow side with an extra-fine-tip Green marker. Fill the branch with Cacao brown and use Coral pink for the top-lit surface.

4.

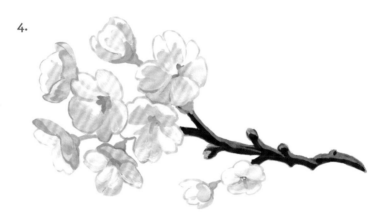

5.

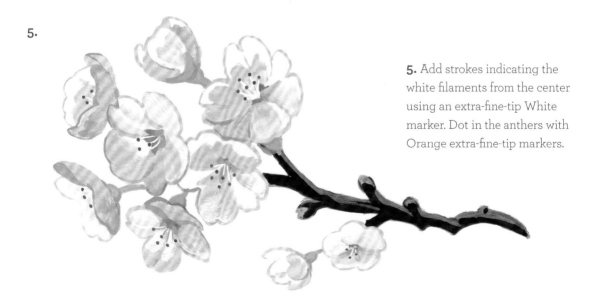

5. Add strokes indicating the white filaments from the center using an extra-fine-tip White marker. Dot in the anthers with Orange extra-fine-tip markers.

CHERRY TREE IN SPRING

Cherry trees may seem unremarkable until they unveil a breathtaking display of pink blossoms in spring. In Japan, the sight of hundreds of cherry trees lining riverbanks and parks adds an extra layer of beauty to the season.

YOU WILL NEED

Markers

Extra-fine tip 0.7mm–1mm

Fine tip 0.9mm–1.3mm

Medium tip 1.8mm–2.5mm

HB pencil

Eraser

Colors (Posca colors in roman, Molotow in italic)

| Light pink | Brown | Pink | Lavender | Cacao brown | Dark brown | White |

1.

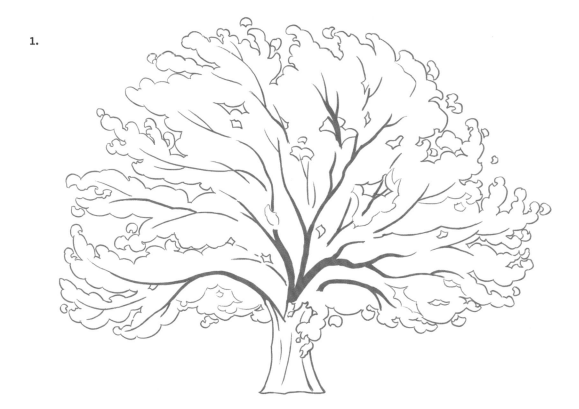

1. Drawing a cherry tree in full blossom may seem daunting at first, so follow these basic steps. Begin by using an HB pencil to sketch a half-circle. Next, draw in the trunk and outline the general placement of the branches. Once the branches are in place, draw cherry blossom clusters along them, following their direction. Use small curved lines to depict the cherry blossom, adding more detail toward the edges.

2.

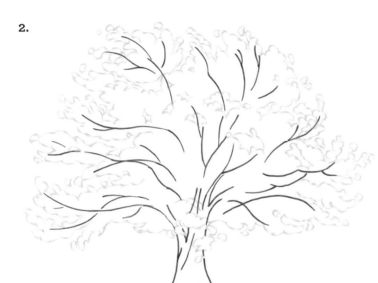

2. Use an extra-fine-tip Light pink marker to trace the cherry blossom clusters, and use an extra-fine-tip Brown marker to outline the tree trunk and the direction of the branches. Although the branches will eventually be covered, they are there to work as a guide since you will be erasing the line art after this point.

3. Begin filling in the cherry blossoms using a medium-tip Pink marker. Leave the top of the tree white as it's more illuminated by a natural light source. Avoid covering the branches completely; let them show through a bit so you can use them as a reference later.

3.

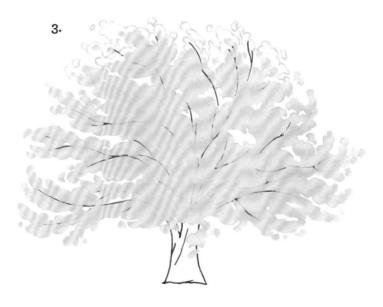

4. Let's enhance the natural, three-dimensional feel by adding shadows. With a medium-tip Pink marker, draw rounded shapes, starting small and enlarging them gradually to depict flower clusters. Blend in Light pink toward the top to soften the edges and lighten the tone.

4.

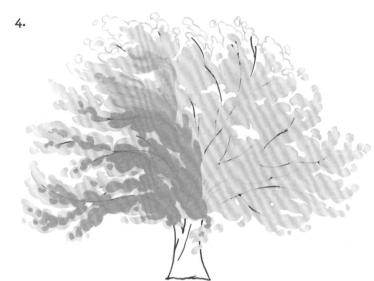

5.

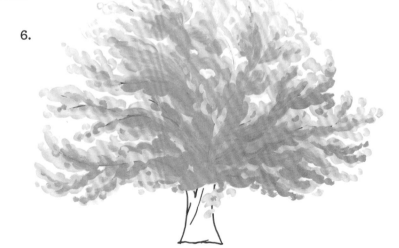

5. Continue adding shadow shapes with a medium-tip Pink marker. As you progress toward the right, use a medium-tip Light pink marker to gently blend and soften all the edges, creating a softer and more natural look. Now work your way back to the left, softening those edges as well.

6. To enhance the lighting and avoid a flat appearance, let's introduce some cooler shadow tones on the right. Grab a medium-tip Lavender marker and draw curved shapes to suggest varying degrees of darkness in specific areas. This will add depth to the drawing.

6.

7. Reintroduce the tree branches using a Cacao brown marker, following the faint direction of the original brown lines as a guide. Feel free to trust your artistic instincts and design the branches naturally to complement the tree's overall appearance. Use Brown and Cacao brown for the trunk.

8. Overlap some cherry blossoms over the branches and trunk using Light pink and Pink. Add shadow to the trunk with Dark brown. Now use a White medium-tip marker to add gaps in the flower clusters. Finally, sprinkle in some falling flower petals for a whimsical touch.

7.

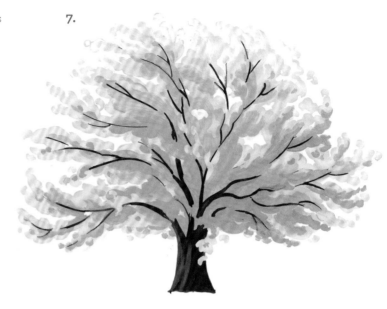

8.

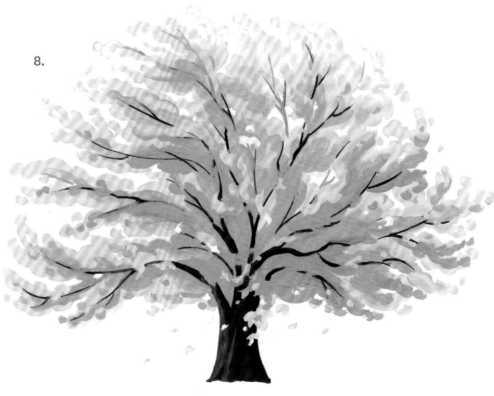

ELM TREE IN SUMMER

During the summer months, elm trees are characterized by dense, vibrant green foliage, creating a lush appearance. Mature elm trees often boast a broad and spreading canopy, lending them a picturesque charm.

YOU WILL NEED

Markers
Extra-fine tip 0.7mm–1mm
Fine tip 0.9mm–1.3mm
Medium tip 1.8mm–2.5mm
Broad bullet tip 4.5mm–5.5mm

HB pencil
Eraser

Colors (Posca colors in roman, Molotow in italic)

Apple green Green Brown Sunshine yellow Yellow Light green White

Aqua green Dark brown Cacao brown

1.

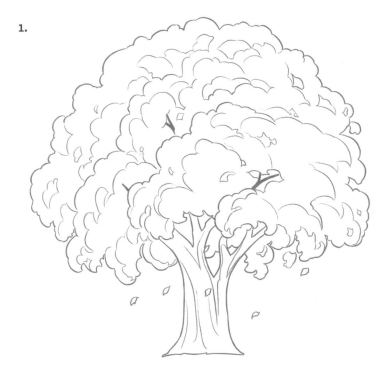

1. To depict the full and broad canopy of the elm tree, start with a half-circle. Sketch larger curves for the lush foliage, and add smaller curves for details. After establishing the overall shape, work on inner shapes to create fullness. Sketch in rounded and non-repetitive shadow shapes throughout the canopy. Draw the tree trunk so that it overlaps the back of the canopy, giving the tree a more three-dimensional appearance.

2.

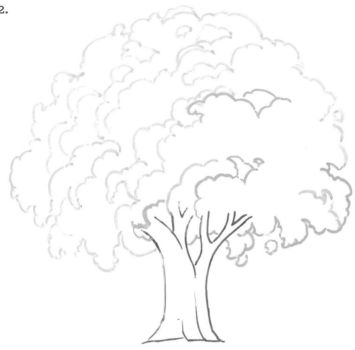

2. Use a fine-tip Apple green marker to trace foliage shapes on the left where the light hits. Switch to a fine-tip Green marker for darker outlines on the right and the canopy's underside. Employ an extra-fine-tip Brown marker for the tree trunk.

3. Fill the illuminated area of the foliage on the left with medium-tip markers in Sunshine yellow and Yellow. Add a touch of Apple green to the Yellow for a greenish tint. Use a medium-tip Apple green marker to outline the shadow shapes and create core shadows. Now apply more Apple green along the edge of the shadow, blending it diagonally into Light green mixed with White to lighten the tone.

3.

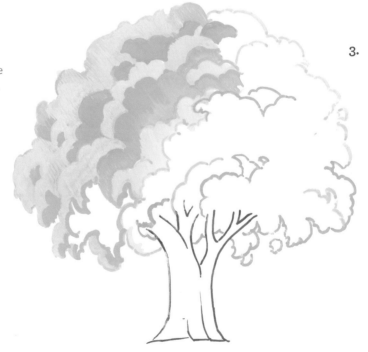

4.

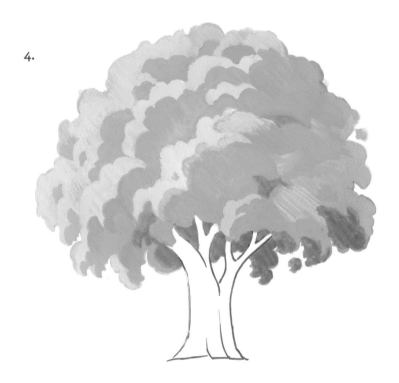

4. Complete the base colors for the canopy by adding cooler greens toward the right using a medium-tip Aqua green marker. Fill in the underside shadow shapes with Green. This adds depth and variation to the foliage.

5.

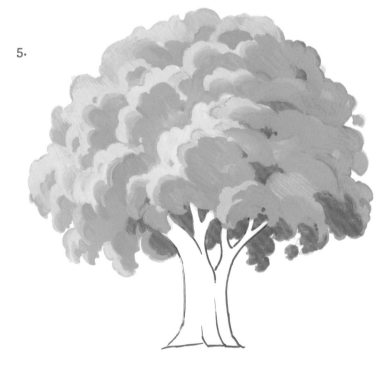

5. To prevent a stiff and unnatural look, blend Yellow along all the Apple green shadow edges on the left. On the right, use Green to blend with Light green to soften the shadow shapes. Add small leaf details to break up the flatness of the foliage, and round out the shapes for volume.

6.

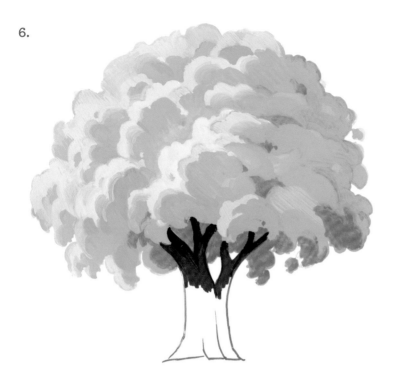

6. The lush canopy casts a dark shadow on the tree branches right beneath it. Use Dark brown for the shadowed area. Switch to a medium-tip Cacao brown marker to continue filling in the top portion of the tree trunk.

7.

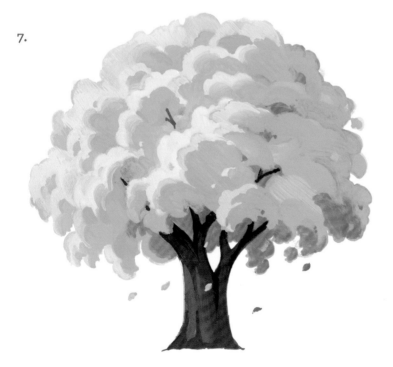

7. Use a broad bullet-tip Brown marker for the left side of the tree trunk, defining its shape with Cacao brown. Introduce Dark brown for the shadow between the two parts of the trunk. Redefine foliage overlapping the trunk, and add falling leaves to bring the drawing to life.

GINKGO TREE IN AUTUMN

Ginkgo trees have unique fan-shaped leaves that turn a brilliant golden-yellow in the autumn, creating stunning landscapes at the height of the season, especially in places where they are abundantly planted, such as Tokyo, Japan.

YOU WILL NEED

Markers
Extra-fine tip 0.7mm–1mm
Fine tip 0.9mm–1.3mm
Medium tip 1.8mm–2.5mm

HB pencil
Eraser

Colors (Posca colors in roman, Molotow in italic)

 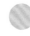

| Apricot | Yellow | Brown | Sunshine yellow | Bright yellow | Cacao brown | Light pink |

1a.

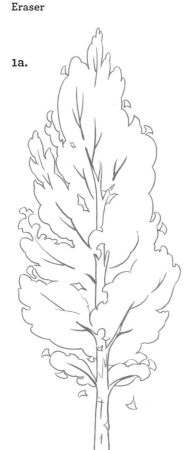

1b.

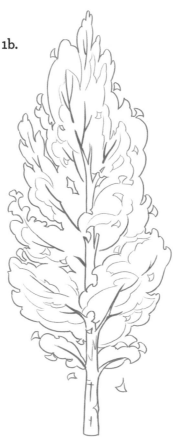

1. Ginkgo trees, famed for their interesting leaves, have a less iconic overall shape. Begin by using an HB pencil to sketch a vertical line indicating the trunk's position, then draw upward-pointing branches. Based on the branch direction, sketch foliage shapes with ginkgo leaves, ensuring a wider bottom and a slightly pointed top.

Once the tree structure is established, add shadow shapes for reference. Lastly, clean up your lines for clarity.

2. Gently lighten the line art, then outline the larger foliage shapes with a fine-tip Apricot marker. Next, use an extra-fine-tip Yellow marker to fill in smaller areas such as the edges of the ginkgo leaves. Finally, trace the main tree trunk with an extra-fine-tip Brown marker, avoiding the smaller branches for now.

3. As the top portion of the tree is closer to the natural light, it appears lighter in color. To depict this, use a medium-tip Sunshine yellow marker to fill in the area of the tree that receives the most light. Plan to create a gradient effect, with the top of the tree brighter and gradually darkening toward the bottom.

4. Use a medium-tip Apricot marker to soften the edges of the Sunshine yellow paint, and fill in the remaining areas of the tree. Focus on the portions of the foliage facing upward, using Sunshine yellow as a highlight to depict form, especially where it overlaps the tree trunk.

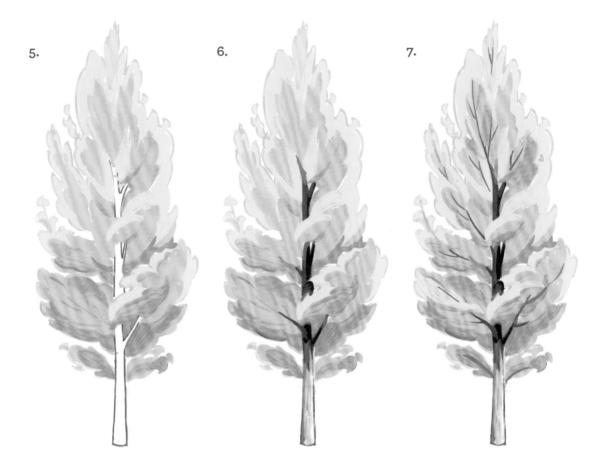

5. To define the foliage shapes further and deepen the coloring, use a medium-tip Bright yellow marker to blend shadow shapes into the lower half of the tree. Use curved strokes to gradually build up volume and create depth. Additionally, add just a few Bright yellow shadows to the upper half of the tree.

6. Time to color the tree trunk. Begin by using a combination of Brown and Cacao brown for the upper portion to establish form, which contrasts nicely against the yellow-orange foliage. Now gradually blend in Light pink for the lower portion to create a faded effect, adding visual interest to the trunk.

7. Use an extra-fine-tip Brown marker to delicately draw thinner tree branches, following the direction of the foliage. Where foliage overlaps, break off the branches to create a natural appearance. Blend Bright yellow into these Brown branches toward the tips to lighten them in areas that require less contrast.

8.

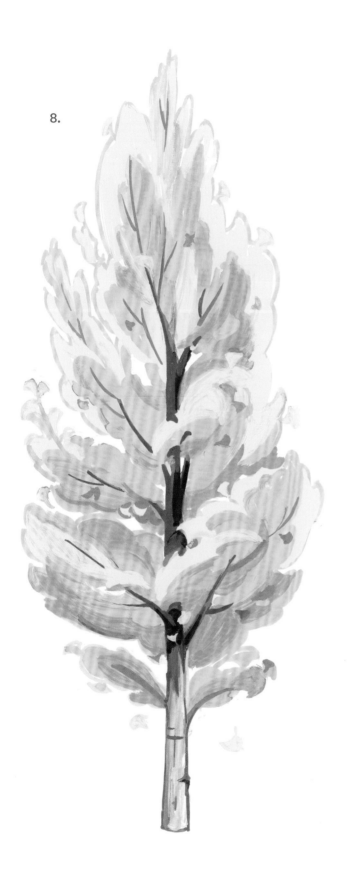

8. The amount of detail you put into a drawing depends on its size and importance within your composition. For a ginkgo tree that is on its own or is meant to stand out within a composition, adding more detail makes it more unique.

To bring out the essence of a ginkgo tree in your drawing, add small ginkgo leaves overlapping the existing foliage. Also include smaller leaves hanging from the branches and gently falling down. Exaggerating the size of the leaves will help convey the idea more effectively.

PINE TREE IN WINTER

Pine trees are evergreens, meaning they retain their green needles through winter. Their deep-green needles create a striking contrast against the delicate snow that softly blankets their branches, making them iconic in winter scenes.

YOU WILL NEED

Markers
Extra-fine tip 0.7mm–1mm
Fine tip 0.9mm–1.3mm
Medium tip 1.8mm–2.5mm

HB pencil
Eraser

Colors (Posca colors in roman, Molotow in italic)

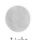

| Light blue | Apple green | Green | Brown | White | Light green | Cacao brown | Dark brown | English green | Sky blue |

1a.

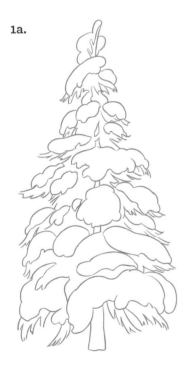

1b.

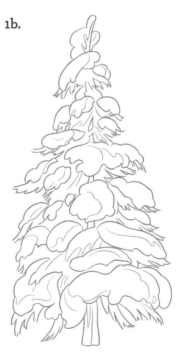

1. Begin by sketching the central trunk of the pine tree using an HB pencil. The branches should radiate outward with shorter and denser ones at the top, gradually lengthening and spacing out toward the bottom. Sketch needlelike foliage following the direction of the branches, then add patches of snow that increase in size on top, following the shape of the foliage. Finally, clean up the lines, and add shadow indications for reference.

2.

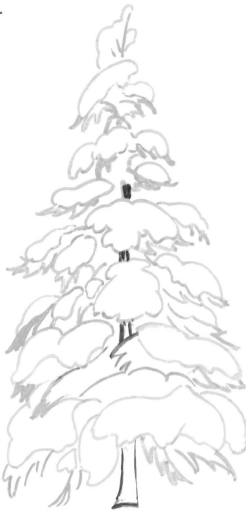

2. Use an extra-fine-tip Light blue marker to trace the snow shapes. Now use fine Apple green and Green markers to outline the needlelike foliage beneath the snow. Finally, use a fine-tip Brown marker to indicate the central trunk.

3. Using medium-tip White and Light blue markers, delicately draw shadows on the snow, blending some of the edges to achieve a soft snow effect. The light, originating from the left, illuminates the left side of the tree. Leave more white space on that side, while gradually adding more Light blue shading to the right.

3.

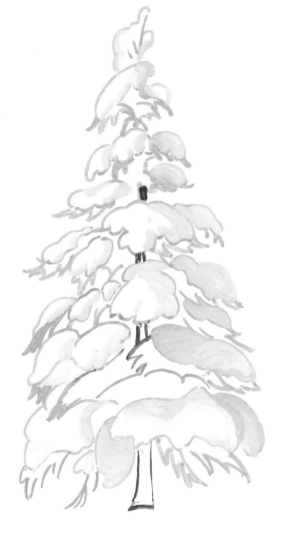

4.

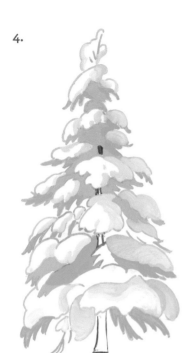

5.

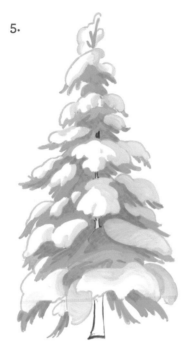

6.

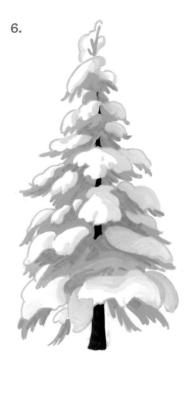

4. With a fine-tip Apple green marker, fill in a base layer for the entire foliage shape beneath the snow, carefully tracing around the White and Light blue to maintain the roundness of the snow. To cool down the warmth of the Apple green marker, you can use a Light green marker toward the center.

5. To add depth and make the foliage appear more three-dimensional like the snow, use a medium-tip Green marker to add shadows. Instead of rounded shapes, use the marker to create strokes that follow the direction of the needlelike foliage. Think in layers and create cast shadows based on the position of the snow on top.

6. This step is quite straightforward, but it's a crucial one. Fill in the central trunk using Cacao brown and Dark brown markers, keeping in mind that the light is coming from the left. To ensure there is sufficient contrast, avoid using light brown for areas beside the greens.

7.

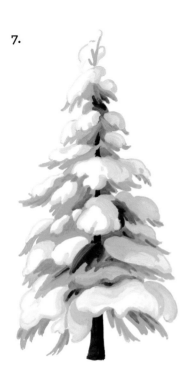

8.

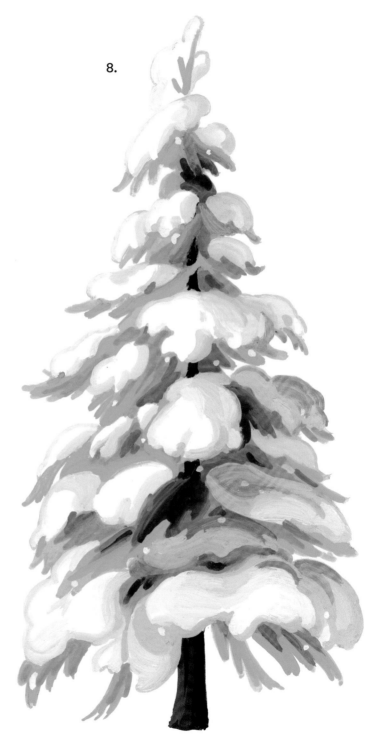

7. To deepen the foliage color and enhance the tree's volume, blend medium-tip English green and Green markers to create darker foliage shapes, focusing mainly on the central area.

8. Grab your medium-tip White and Light blue markers and sprinkle in some dots to represent snowflakes. Mix Sky blue into the existing Light blue snow shadow on the right to darken it. Next, blend medium-tip English green with Green to add depth to the area beneath the snow.

COMPOSITION

Composition is undoubtedly one of the most important aspects of any artwork, serving as the essential foundation upon which a great artwork is built. Here we explore helpful tools for creating a strong composition.

COMPOSITIONAL TOOLS

The techniques and principles of composition, in particular framing, leading lines and the rule of thirds, are used by artists to create captivating artwork that draws in viewers and effectively conveys their artistic vision.

Framing
Use foreground elements and lighting strategically to frame key parts of the design, ensuring that the viewer's attention does not wander to less important elements.

Leading lines
Intentionally add directional elements or use naturally occurring lines based on perspective to guide the viewer's attention toward the key elements of the composition.

Rule of thirds
Divide the canvas into thirds both horizontally and vertically, then position key elements along these lines, or at the intersections of the lines, to create balance and visual impact.

PLANNING A COMPOSITION

Utilize various compositional tools to draw attention to the focal point, while simultaneously creating balance and depth within the design.

Orientation and aspect ratio
First, decide on the composition's orientation – horizontal or vertical – to create different moods. Additionally, choose the aspect ratio (the shape expressed as the ratio of width to height): Is the composition going to be square, rectangular or panoramic?

Focal point
Apply the rule of thirds to determine the placement of the focal point, ensuring it stands out enough to draw attention without being overshadowed by other elements in the composition.

Balance
Use negative spaces (empty areas) of the composition to balance the heavy visual weight of the main elements.

Depth
To enhance depth in a composition, push the background away, focus on the midground for the main elements and introduce foreground elements to frame the focal point and enhance the overall sense of depth.

ATMOSPHERE & LIGHT

Atmosphere and light are crucial aspects that contribute to the mood, depth and realism of an artwork. They also play a significant role in guiding the viewer's attention within the composition, drawing the eye to key elements.

ATMOSPHERIC PERSPECTIVE

The visual phenomenon known as atmospheric perspective, which is observed in landscapes and other scenes, causes distant objects to appear less distinct, less detailed and often lighter in color than closer things. This effect occurs as distant objects gradually take on the color of the sky due to the scattering of light in the earth's atmosphere.

Shift colors

With more atmosphere between the object and the viewer, distant objects gradually take on the color of the atmosphere or, in other words, the sky – they shift toward blue on a clear day and during the blue hour, and shift toward orange during sunrise and sunset.

Reduce contrast

Atmospheric scattering reduces distant objects' contrast with the background, making them appear less distinct than closer objects.

Lessen details

The detail of distant objects is less defined, and contrast within the layer is reduced, the farther away the objects are, making them appear more like silhouettes.

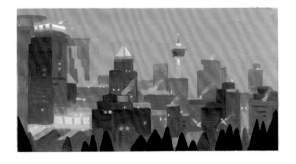

LIGHT

Understanding how light influences colors, casts shadows and varies across different sources is crucial for creating a believable painting.

Types of light sources

There are various types of light sources, including natural (sunlight, moonlight), artificial (streetlights), ambient (reflected light), directional (spotlight, backlight) and diffused (cloudy sky). Determining the dominant light source can help you understand how light affects colors and shadows in a painting.

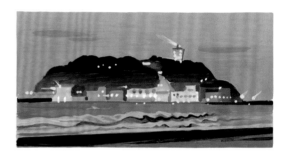

Natural moonlight + artificial lights

Color temperature

Light affects color temperature, with warm light (such as sunlight, candlelight) creating warmer tones, and cool light (moonlight, fluorescent light) producing cooler tones. Adjust your palette based on how light influences colors in your scene.

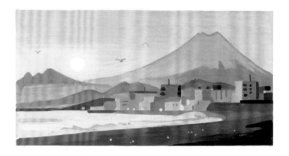

Warm low-angled sunlight

Intensity and direction

The intensity and the direction of light play a significant role in shaping the appearance of colors and shadows. Light intensity determines the darkness and sharpness of cast shadows, while light direction can alter the length of the shadows.

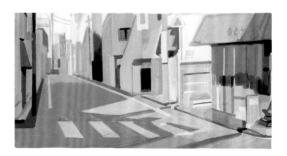

Long-cast and sharp-cast shadows

CAST SHADOW & TEXTURE

An artist can enhance an otherwise flat drawing in various ways. One technique involves adding cast shadows to frame the composition and guide the viewer's attention. Another effective method is adding texture to different surfaces to introduce visual interest.

CAST SHADOW

A cast shadow is a dark area where an object's mass has prevented light from reaching the surface behind it. Cast shadows can vary in length, shape and opacity depending on the angle and intensity of the light source. Adding cast shadows to your drawings can enhance realism and strengthen a composition.

Cast shadow edge

The shadow will have sharper edges closer to the object that's casting it; the farther it gets, the blurrier the edge will become. Hard light, such as when the sun is high in the sky on a clear day, casts a sharper shadow, while soft light, such as the light on an overcast or cloudy day, casts a softer shadow.

Cast shadow color

Cast shadows reflects the color of any secondary light source adding illumination; for example, the blue of the sky can make shadows appear bluish on a clear, sunny day. If the cast shadow is falling on a warmer-toned surface, or if the sky is overcast, it will simply appear as a desaturated, darkened shade of the local color.

TEXTURE

To help create distinction between different surfaces, consider adding some texture to the base layer of your drawing. Control contrast and repetition to avoid distraction.

Base layer

Before you add any texture to a surface, you should already have blocked in the base layer. Be sure to add any tonal gradation and cast shadows as part of this layer.

Texture

Based on the colors you used to block in the base layer, select shades that are only slightly darker or lighter to add texture. Use darker colors for areas in shadow, but vary the shades to maintain mostly low contrast. Avoid repetition and excessive detail, leaving some areas empty.

Clarity

Add texture only to the surface areas that are closest to the viewer, as details tend to blur with distance. For background surfaces, significantly reduce the clarity and contrast of the texture. Some low-contrast strokes to suggest a change in color are sufficient.

HELPFUL TIPS

Here are some final tips to consider before embarking on your projects. Keeping these in mind will make your experience with paint markers more enjoyable and effective.

LIGHTEN YOUR LINE ART
After you've solidified your composition and cleaned up your line art, gently dab it with a softer eraser to lighten it, especially in the areas where you will be using lighter colors. Ensure the rest of the line art is dark enough for you to see but light enough to be covered by paint later.

LAY OUT YOUR MARKERS
Decide on your color scheme and lay out the colors you'll need on your table. Arrange them by temperature and value, with cool colors in one row and warm colors in another for easy access.

GRADIENTS FIRST
If you plan to fill in an area with a gradient but have other details to overlap, start by painting over the entire area with a complete gradient first, and then add the details afterwards. That way, the gradient will be uninterrupted, resulting in a smoother look.

BE PATIENT
To prevent accidental smudging or blending, allow each painted section to fully dry before working on adjacent areas, especially if you're not planning to mix or blend colors. Rushing this process can lead to unwanted smudges and make corrections more challenging later on.

IS THERE ENOUGH CONTRAST? IS THERE TOO MUCH?
With each new block of color you add, keep in mind its value compared with the colors around it. Does it stand out? Is it dark enough, or too dark? Take a moment to step back from your artwork and assess whether the contrast is working effectively.

PAPER SIZE
The size of the marker tips and the complexity of the composition both determine the ideal paper size for your work. I recommend opting for a smaller size, ranging from 4 in. x 6 in. (105mm x 148mm) or 5 in. x 7 in. (127mm x 178mm).

THE PROJECTS

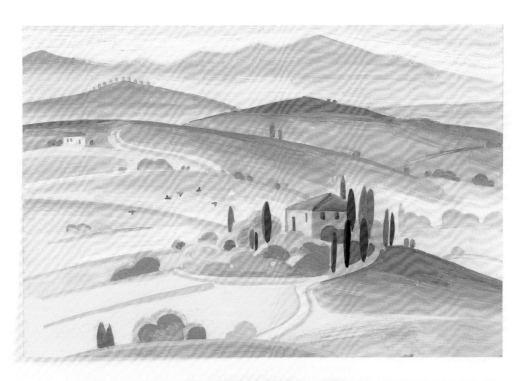

SNOW-COVERED MOUNTAIN

This is a snowy scene based on a mountain view seen from Mount Baker in the Canadian Rockies. The emphasis is on capturing the striking contrast between the glistening snow, the shadows on the mountain and the background.

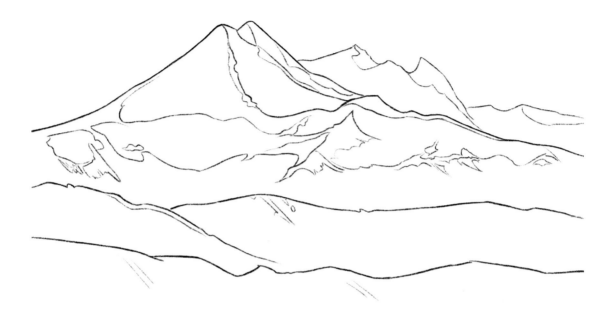

YOU WILL NEED

Markers

Extra-fine tip 0.7mm–1mm
Fine tip 0.9mm–1.3mm
Medium tip 1.8mm–2.5mm
Broad bullet tip 4.5mm–5.5mm

HB pencil

Eraser

Washi tape

Colors (Posca colors in roman, Molotow in italic)

 Light pink
 Light orange
 Light blue
 Ivory
 White
 Blue violet pastel
 Lilac

 Sky blue
 Emerald green
 Shock blue

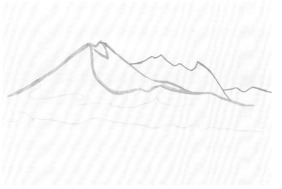

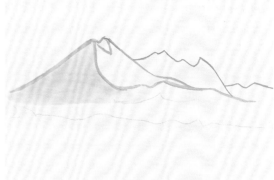

1. Define the left side of the mountaintop facing the light source with fine-tip markers in Light pink and Light orange. Use both fine-tip and extra-fine-tip markers in Light blue to outline the shadow shape and the background mountain.

2. To fill in the mountains, begin with the lighter colors – Ivory, Light orange and Light pink – to create a smooth gradient for the part of the snow-covered mountain that faces the light source.

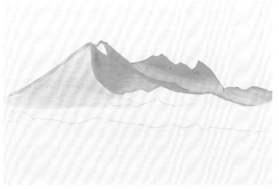

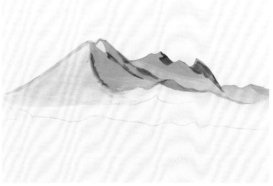

3. Use broad bullet-tip markers in Light blue and White to create a gradient on the shadow side of the front mountain, so it is darker at the top and lighter at the bottom. Apply the same gradient to the back mountains, creating contrast between the layers.

4. Wait until the base colors are completely dry, then add details. Use medium-tip *Blue violet pastel* and Lilac markers to deepen the edges of the shadow shapes, portraying part of the mountain peeking through the snow.

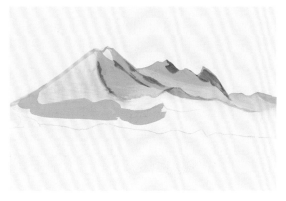
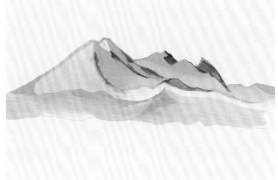

5. To create the cast shadow on the snow, use an extra-fine-tip Light blue marker to first outline the shadow edge. Then, with a broad bullet-tip in Light blue, begin filling in the shadow. Proceed swiftly to the next step before the paint dries.

6. Before the Light blue paint dries, swiftly use a broad bullet-tip in White to blend it outward. Achieve contrasting soft and hard edges by using a medium-tip Light blue marker to refine and sharpen some of the edges.

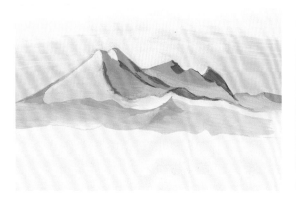
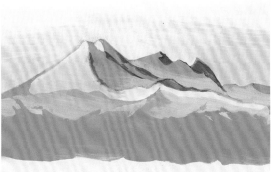

7. Fill the sky with Light orange and Ivory broad bullet-tip markers. The warm tones of the sky will create a striking contrast against the coolness of the shadow on the mountain. Add White near the Light pink edge to separate the snow from the sky.

8. Apply an opaque layer of Light blue on top of the existing cast shadow area. Use a fine-tip Light blue marker to add sharp edges that depict the ruggedness of the mountain. Leave the bottom section empty for foreground colors.

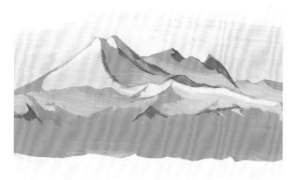
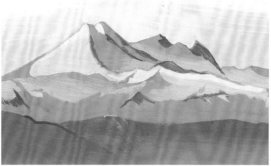

9. Use a fine-tip Sky blue marker to add additional sharp-edged shadow shapes, further enhancing the rugged appearance of the mountain.

10. Apply Emerald green for a foreground mountain layer. Transition the bottom section into Light blue in preparation for creating a separation between this layer and the next.

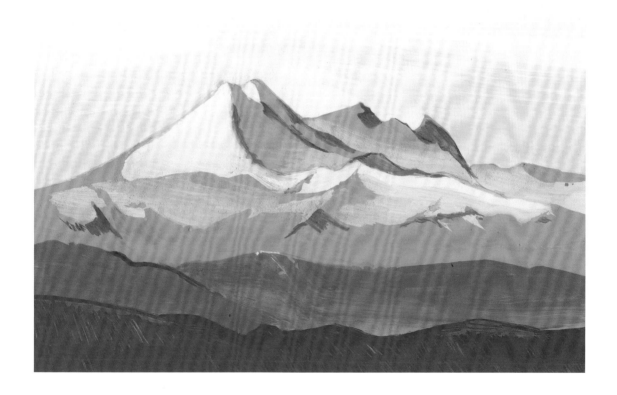

11. Apply *Shock blue* for the final layer of the foreground hill. (Alternatively, use Turquoise blended with Navy blue.) Ensure that this layer is the darkest in the entire composition.

MOONRISE IN LUCERNE

In Lucerne, Switzerland, the iconic footbridge known as the Kapellbrücke, or Chapel Bridge, is situated just west of the Seebrücke road bridge, while the Swiss Alps adorn the eastern horizon. In early autumn, the moon rises gracefully over the peaks, creating a beautiful composition.

YOU WILL NEED

Markers

Extra-fine tip 0.7mm–1mm
Fine tip 0.9mm–1.3mm
Medium tip 1.8mm–2.5mm
Broad bullet tip 4.5mm–5.5mm

HB pencil

Eraser

Washi tape

Colors (Posca colors in roman, Molotow in italic)

Ivory Aqua green Light blue Sky blue *Shock blue* Navy blue *Ceramic light pastel* White

Emerald green Light pink

1. Fill in the moon using Ivory, and before the Ivory paint dries completely, encircle it with Aqua green for a gentle, warm glow. Now blend the Aqua green into Light blue for a seamless transition.

2. Before working on the sky, establish the values of the mountain and hill layers by outlining their edges. Use a fine-tip marker from back to front with a progression from light to dark: Light blue, Sky blue, *Shock blue* and finally Navy blue.

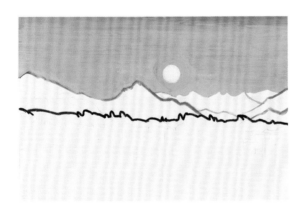

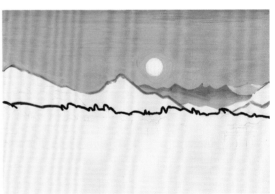

3. Horizontally fill the sky with a broad bullet-tip marker in Light blue. Blend it into *Ceramic light pastel* at the top, creating a slightly darker shade as you move away from the moon.

4. Start filling in the back layers of the mountains. To create contrast, mix White into Light blue for the snow-covered mountain farthest back, and use Sky blue at the top blending into Light blue for the mountain in front of it.

5. Continue with the next layer in front on the right side using the same colors as the previous layer: Sky blue at the top blending into Light blue. Add a touch of *Shock blue* at the edge to distinguish it from the layer behind.

6. For the next and most prominent mountain layer in the composition, apply *Shock blue* at the top, blending into Sky blue. Use a medium-tip Sky blue marker to create diagonal blends, suggesting the ruggedness of the mountain surface.

7. Outline the horizon with Emerald green before working on the darkest midground hill, which would display greenery by day but blends into mostly an ambiguous dark shape at night. Use Emerald green and Navy blue predominantly for this section.

8. To make this area more interesting, start by drawing simple house shapes using Light pink and Light blue. Now carefully fill in Emerald green and Navy blue around them, creating sharp edges on one side and overlaying foliage shapes on the other side.

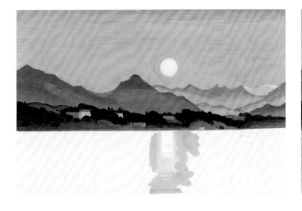

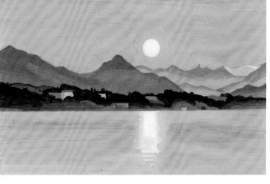

9. Apply medium-tip Ivory and broad bullet-tip Light blue for the reflection of the moon, starting with Ivory and blending in Light blue along the edge in a horizontal motion.

10. Fill the water with a broad bullet-tip marker in Light blue, then blend in horizontal strokes of Sky blue in the middle section for added depth and movement.

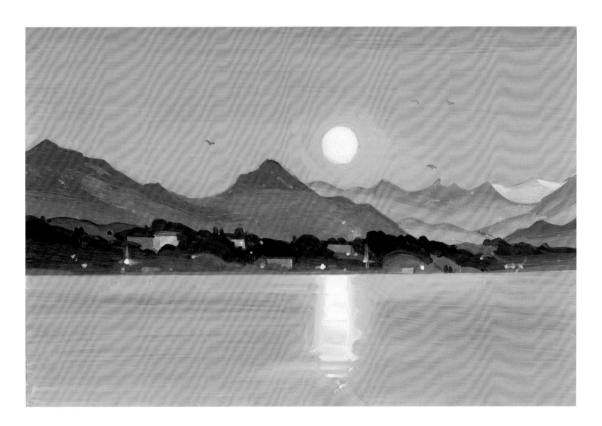

11. Create glowing lights using an extra-fine-tip White marker, along with medium-tip Ivory and White markers. Gently smudge the paint upward and sideways to give it a sparkling effect.

SUNRISE IN TUSCANY

Tuscany's beauty is unparalleled – its rolling hills and iconic cypress trees offer endless inspiration for captivating compositions. It's especially lovely in the early morning, when light separates each layer, creating breathtaking scenes.

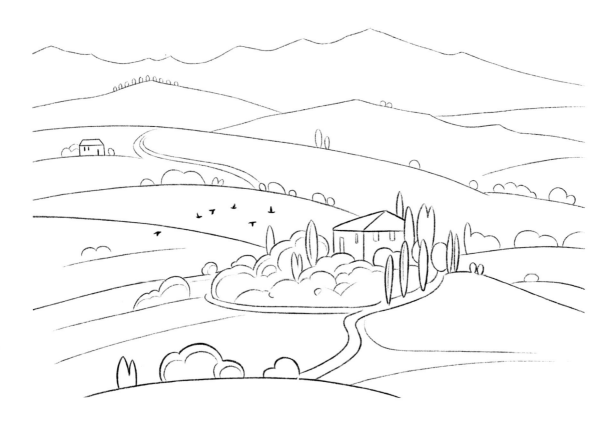

YOU WILL NEED

Markers

Extra-fine tip 0.7mm–1mm
Fine tip 0.9mm–1.3mm
Medium tip 1.8mm–2.5mm
Broad bullet tip 4.5mm–5.5mm

HB pencil
Eraser
Washi tape

Colors (Posca colors in roman, Molotow in italic)

| Sunshine yellow | *Powder pastel* | Light pink | Pink | *Ochre brown light* | Brown | Light orange | Orange | Dark brown |

| Straw yellow | Ivory | Coral pink | Apricot | White | Beige |

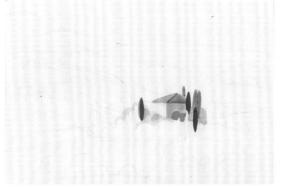

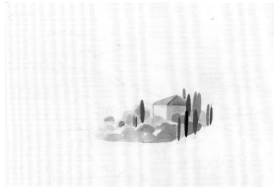

1. The surfaces facing the left side, where the sun rises, are lighter and warmer. Contrast the house's walls with Sunshine yellow and *Powder pastel* against cooler tones in Light pink and Pink. Depict trees using *Ochre brown light* and Brown, and add Light orange to the bush tops.

2. Finish the focal point by filling in the bushes with a mix of Light orange and Orange, leaving gaps of Sunshine yellow for highlights. With Dark brown and Brown, introduce darker cypress trees in front, varying their sizes and shades to enhance depth and variation.

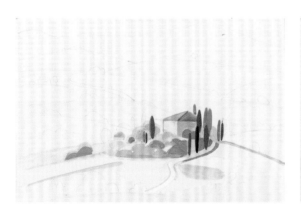

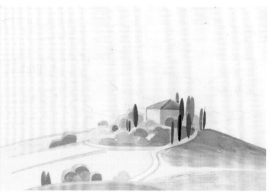

3. Apply Sunshine yellow to the sunlit area. Introduce Straw yellow lines and an Orange bush to break up the flat shape. Use Light orange to outline the Ivory-colored path. On the right side of the path, blend Light orange into Sunshine yellow to prepare for transitioning to a darker color.

4. Continue on the right side of the hill, transitioning to the shadowed area by blending Light orange into Orange. Cool down the area behind the house by adding Coral pink. Introduce Straw yellow for the darker section near the very front, and then depict the foreground hill and bushes with Apricot and Orange.

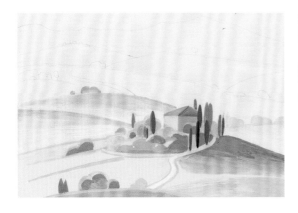

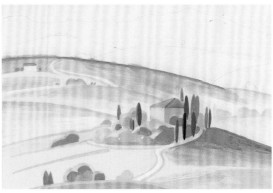

5. To bring out the focal point, fade out the area just behind it. Blend Ivory and White, transitioning to Light orange for the immediate hills behind. Introduce a Sunshine yellow layer for separation. On the right, use Beige with Light pink for foliage and Ivory with Light orange for the hill.

6. Incorporate a partially shadowed hill by darkening its edge with Orange, blending downward into Light orange. Introduce a pathway in White to lead the eyes to the focal point and a small house in Ivory to add interest to the scene.

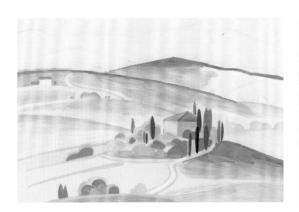

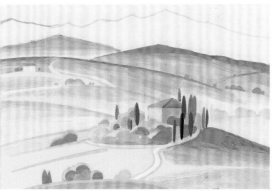

7. Start a new hill layer by defining the edge with darker colors, progressing from Pink to Orange using medium-tip markers. Blend the edges into Light orange with a broad bullet-tip marker.

8. Continue blending the Orange edge into Light orange. Add lines and foliage shapes with Coral pink for interest and separation from the shape in front. Use Apricot with a bit of Orange blending into Ivory for the layer behind on the left.

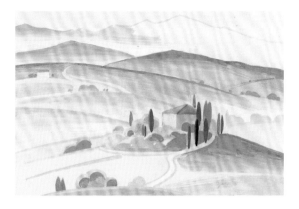 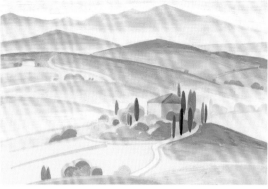

9. For the foremost back layer, outline the top edge with Coral pink on the left and Light orange for the rest. Blend into Sunshine yellow and Ivory on the left.

10. Finish the back layer by blending Light orange into Ivory. For the sky, use Ivory mixed with White, adding a touch of Light orange at the top for a subtle transition.

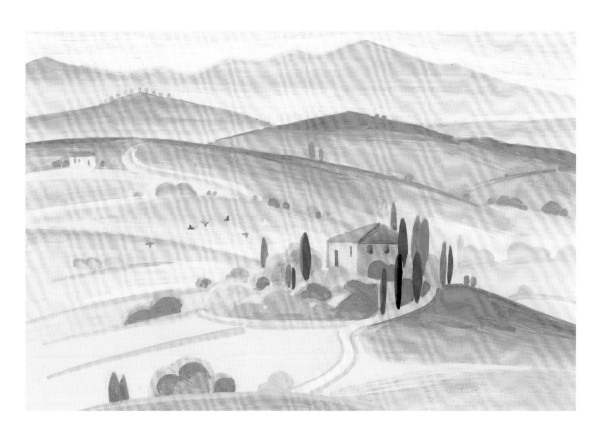

11. Use extra-fine-tip Orange and Brown markers to add windows on the houses and indicate trees in the distance. Enhance the scale of the scene with tiny birds for a touch of whimsy.

MISTY MORNING IN ÓBIDOS

Early one summer morning during my charming stay in Portugal, just outside the walls of Óbidos castle I came upon this breathtaking scene. Anticipating an ordinary sunrise, I was greeted by a stunning misty ambience that made everything even more dreamy.

YOU WILL NEED

Markers

Extra-fine tip 0.7mm–1mm

Fine tip 0.9mm–1.3mm

Medium tip 1.8mm–2.5mm

Broad bullet tip 4.5mm–5.5mm

Broad chisel tip 5.5mm–8mm

HB pencil

Eraser

Washi tape

Colors (Posca colors in roman, Molotow in italic)

| Light blue | White | Lilac | Brown | Lavender | Aqua green | Emerald green | Beige | Light pink |

| Navy blue | *Powder pastel* | *Lilac pastel* | *Blue violet pastel* | Turquoise |

1. Start with the focal point, the distant church. Add in a bit of Light blue paint as the base, blending it with a broad bullet-tip White marker while it's still wet, to achieve a lighter blue shade. Apply Lilac for the roofs, and add a touch of Brown to the sides.

2. Utilize a fine-tip Lavender marker for detailing the church's surface. Tilt the paper as you draw to achieve straighter lines. Add Lilac sparingly for darker details, as they can draw excessive attention if overused.

3. Use Aqua green and Emerald green for the trees. For the small houses by the church, apply Beige and Light pink for their walls. Use Lilac for the roof areas not bordering the Emerald green foliage, and Navy blue for areas in contact with the greenery, to create contrast.

4. Continue blocking in the surrounding area with reduced contrast. Apply Beige, Light pink, *Powder pastel* and White mixed with Light blue for walls; *Lilac pastel* and Lavender for roofs; Aqua green and Light blue for foliage.

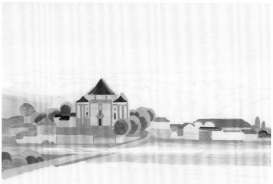

5. Block in the houses on the right side of the composition using the same colors as those on the left edge to maintain consistent contrast, as they are at the same distance. Incorporate *Blue violet pastel* and Lilac for the darker roofs.

6. Introduce mist across sections of the ground by blending White and Light pink horizontally. Outline the pathway with Light pink, Lavender and Light blue. In the foreground, create darker bushes using Aqua green, Light blue and Emerald green.

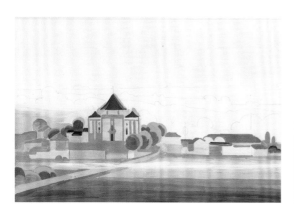

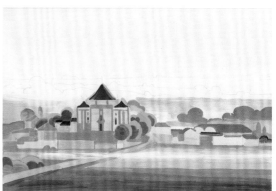

7. The ground area not covered by mist is notably darker, especially the section closest to the viewer. Apply Emerald green blended with Turquoise and a touch of Navy blue for the darkest region. Transition to *Blue violet pastel* and finally to *Lilac pastel*.

8. Blend *Blue violet pastel* with *Lilac pastel* for the foliage in the back, as it's warmer being closer to the rising sun. Create a separation from the foreground by blending in white. Use Light pink and white for the mist behind it.

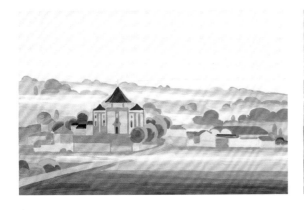

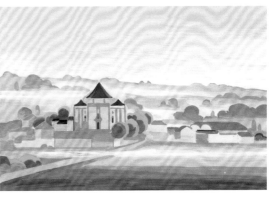

9. Draw the distant hills with rounded shapes to imply foliage, using *Lilac pastel* and Light pink. Apply a layer of White at the bottom for separation.

10. Create a gradient in the sky starting with Ivory where the sun is about to rise, blending into Beige and Light pink. Add White for separation on the left.

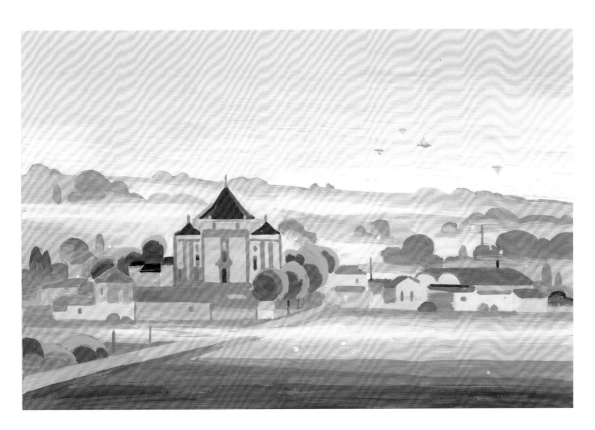

11. Use an extra-fine-tip White marker for highlights and employ fine-tip Lavender and Lilac markers for darker details. Add birds with faded colors in the sky to enhance the mood.

BLUE HOUR IN LISBON

Lisbon's Miradouro das Portas do Sol is one of the city's finest viewpoints. As the sun rises over the sea level horizon, the Alfama district is bathed in warm sunlight. I highly recommend arriving even before sunrise to relish the serene and magical blue hour, casting a beautiful blue tint over the houses.

YOU WILL NEED

Markers

Extra-fine tip 0.7mm–1mm
Fine tip 0.9mm–1.3mm
Medium tip 1.8mm–2.5mm
Broad bullet tip 4.5mm–5.5mm

HB pencil

Eraser

Washi tape

Colors (Posca colors in roman, Molotow in italic)

Light blue	Sky blue	Light orange	Brown	Coral pink	Dark brown	*Powder pastel*	Navy blue	Emerald green

Ivory	White	Light pink	Beige	Lavender	Lilac	Violet	Green	*Blue violet pastel*	*Lilac pastel*

1. Begin by outlining the edges of the church tower with extra-fine-tip and fine-tip markers. Use Light blue for the edges touching the sky and Sky blue for the shadowed areas. Fill in the small opening with Light orange, and add a Brown edge to convey the illumination from inside.

2. Fill the opening on the opposite side with Light orange and Coral pink, with a Dark brown edge for definition. Proceed to fill the entire tower using Light blue, adding a touch of *Powder pastel* for the warmer surface facing the front. Blend in Sky blue with a hint of Navy blue for the darker edges of the tower.

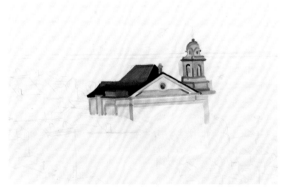

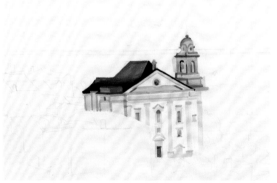

3. Blend Emerald green into Navy blue for the rooftop. Fill in the base wall color, blending Ivory into White with a touch of Light pink for the brightly lit front wall. After the base color dries, introduce Beige, Light pink, Light blue, Lavender and Lilac for the darker details on top.

4. Continue using fine-tip Beige and Light pink, along with Light blue, to outline the columns and windows on the front surface of the church. Use Lilac for detailing darker elements like the doorway at the bottom.

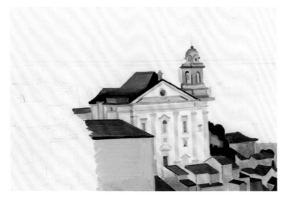 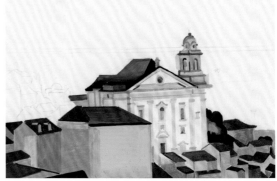

5. To enhance contrast with the focal point, begin filling in the foreground house and the tree behind. Given the blue hour setting, use Light blue for the house walls and create a roof with a blend of Sky blue and Violet. For the tree, use a combination of Green, Emerald green and Navy blue to create the partially lit effect.

6. Fill the walls of the small houses with Light pink, Lavender, Light blue and *Blue violet pastel*. Use Violet and Navy blue for the roofs. Blend in warm colors such as Ivory, Light orange and *Powder pastel* in areas illuminated by a warm light.

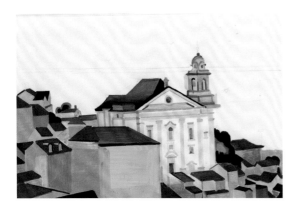 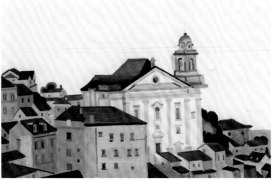

7. Complete the other houses using the previously employed colors. Use Sky blue for walls in shadow. In the back on the left side, use Emerald green and Navy blue to depict the tiny tree peeking out.

8. Take your time as you add windows, ensuring they don't overcrowd the surfaces. Keep the windows in the background simple, adding slightly more detail to those of the foreground building.

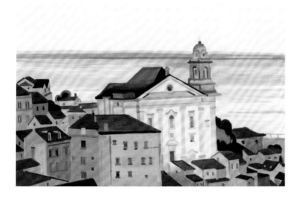

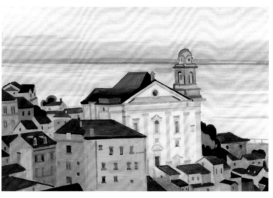

9. Use Lavender and *Blue violet pastel* to outline the horizon. Now create a gradient from *Lilac pastel* to Light pink and then add some horizontal streaks of *Lilac pastel*, depicting the sea.

10. Create a gradient in the sky by blending from Ivory mixed with Beige, transitioning to Light orange, and finally fading to Light pink near the horizon.

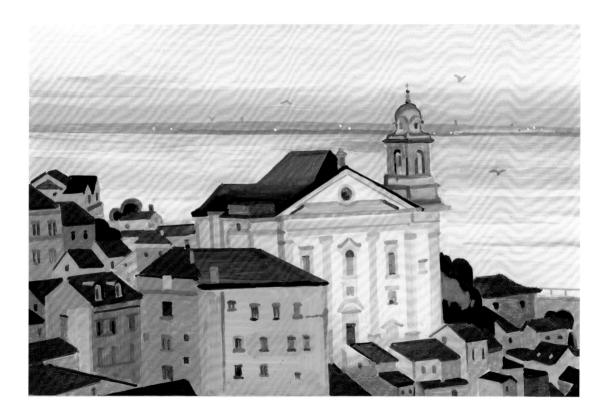

11. Dot in small glowing lights on the distant horizon using White extra-fine-tip markers. Then use darker extra-fine-tip markers to depict birds, adding a sense of movement.

TWILIGHT IN FLORENCE

Piazzale Michelangelo provides the most stunning vistas of Florence. As dusk settles, a gentle warmth lingers in the sky, contrasting with the city's cool tones. The cityscape comes alive as shimmering lights illuminate the scene.

YOU WILL NEED

Markers

Extra-fine tip 0.7mm–1mm
Fine tip 0.9mm–1.3mm
Medium tip 1.8mm–2.5mm
Broad bullet tip 4.5mm–5.5mm

HB pencil

Eraser

Washi tape

Colors (Posca colors in roman, Molotow in *italic*)

| Ivory | Light orange | Light pink | Violet | Lavender | *Blue violet pastel* | Lilac | Emerald green | Navy blue |

| Light blue | Sky blue | Brown | *Powder pastel* | Sunshine yellow | Beige |

1. To establish the focal point, begin with Ivory, Light orange and Light pink to fill in the illuminated area of the tower. Use an extra-fine-tip Violet marker to draw the pointy roof. Use a fine-tip Lavender marker to outline the shadowed regions on the tower and the top of the dome next to it.

2. For the surrounding houses, apply Light orange and Light pink to one side of the walls. On the shadowed sides, blend Lavender and *Blue violet pastel*. Use Lilac and Violet for the roofs, plus Emerald green and Navy blue for small foliage details.

3. Continue by blocking in houses and adding tree shapes over existing structures. Transition to darker and cooler tones for the houses in front, using Light blue for walls and Sky blue for shadows. This will enhance the contrast and depth of the scene.

4. Paint the rooftops of the foreground houses using Lilac and Navy blue. Introduce shadow elements with Brown and Navy blue to ensure that the foreground appears the darkest.

 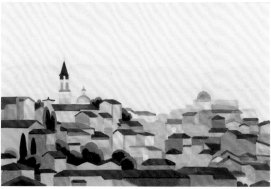

5. Draw the houses on the right. Use *Blue violet pastel* and Lilac for roofs and Light pink, Light blue and *Powder pastel* as wall colors to reduce contrast and to blend better into the background. Incorporate Sunshine yellow to highlight the dome of the cathedral.

6. Finish all the houses with previously used colors, ensuring the ones in the foreground are darker. Choose colors based on their tonal value so that each shape stands out against the others. Introduce touches of Light pink and Light orange to add variety and break the monotony within the scene.

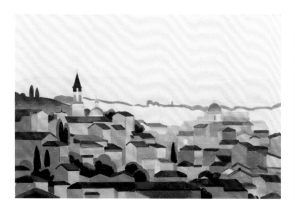 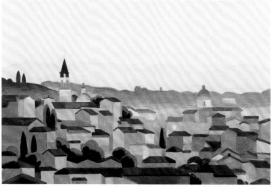

7. Address the background layers of hills by using Lilac and *Blue violet pastel* for the hill closest to the city on the left, suggesting the presence of cypress trees. Next, use a medium-tip Lavender marker to outline the layer behind it.

8. Fill the silhouette of the background hill by blending *Blue violet pastel* at the top into Lavender, and using Light pink at the bottom. This combination ensures that the top is distinct, while the lighter bottom allows the layer in front to stand out more.

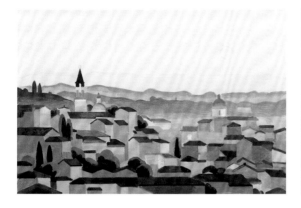

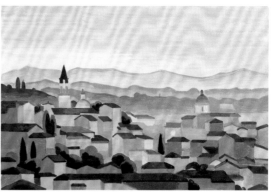

9. Create the back layer using uneven rounded shapes to imply scattered foliage. Blend Lavender into Light pink to create a soft transition between the colors.

10. Draw the distant mountain using *Lilac pastel*, blending it into Light pink. Fill the sky starting with Ivory, and blend upwards into Beige and Light orange to enhance the contrast in the composition.

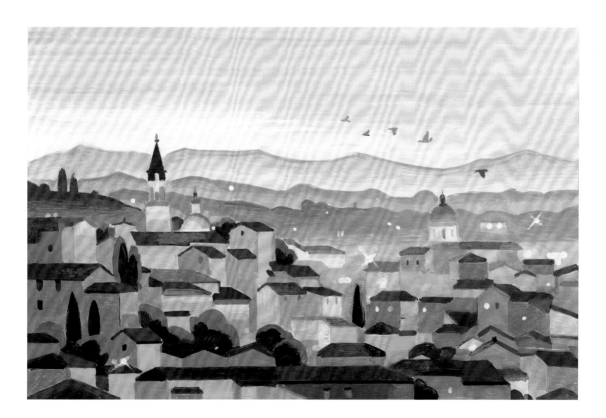

11. Use an extra-fine-tip White and a medium Ivory marker for house lights and highlights in the distant layers. Add small birds flying sideways to add movement to the scene.

GOLDEN HOUR IN FLORENCE

Florence is among Italy's most beautiful cities, and I love standing on its bridges to take in the splendid views. This scene was captured from Ponte Vecchio during the golden hour, looking toward the west.

YOU WILL NEED

Markers
Extra-fine tip 0.7mm–1mm
Fine tip 0.9mm–1.3mm
Medium tip 1.8mm–2.5mm
Broad bullet tip 4.5mm–5.5mm

HB pencil
Eraser
Washi tape

Colors (Posca colors in roman, Molotow in italic)

| Light orange | Orange | Brown | Pink | Beige | *Powder pastel* | Light pink | Coral pink | Dark brown |

| Light green | Aqua green | Green | Straw yellow | Emerald green | Sunshine yellow | *Lilac pastel* | *Blue violet pastel* |

1. Start with the buildings with interesting cast shadows on them. Use Light orange for the areas that are illuminated, and opt for Orange for the cast shadows. Apply Brown mixed with Orange for the rooftops and Brown mixed with Pink for the surfaces facing away from the light.

2. Proceed by blocking in colors around the focal point. Diversify the wall colors with Beige, *Powder pastel*, Light pink and Coral pink. Apply Brown for the roofs, and use a fine-tip Dark brown marker for their shadows. Apply Light green, Aqua green and Green for foliage.

3. Before addressing the background layers, block in all the remaining buildings along the riverbank using the same color palette as before. Trace the top edges of the tower with an extra-fine-tip Orange marker to ensure that it stands out prominently.

4. Continue by working on all the foliage behind the focal point area. Using medium-tip markers to depict the roundness of the trees, apply Straw yellow and Light green for the lighter areas, and Aqua green and Emerald green for the cooler areas.

5. Continue refining the foliage shapes, extending them toward the left side of the composition. Incorporate Sunshine yellow into Straw yellow to make certain trees stand out more prominently.

6. Draw the hill behind the tower using Light pink, Beige and *Powder pastel*. Add a touch of White at the bottom for a faded effect, allowing the elements in front to stand out more.

7. Time to draw in some puffy clouds. Use Beige and Light orange to outline the outer edges of the clouds for a glowing effect. Incorporate Pink, Beige and a touch of *Powder pastel* for the inner shadow shapes.

8. Blend the Beige edges of the clouds into the Light pink of the sky to enhance the glowing effect. Add a bit of White to lighten the Light pink for the area of the sky touching the background hill.

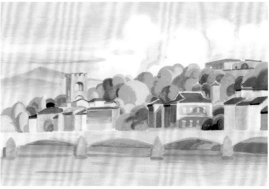

9. Opt for warm colors like Light orange, Beige, *Powder pastel* and *Lilac pastel* instead of grays to paint the bridge, better complementing the rest of the painting.

10. Apply *Lilac pastel* for the cooler section of the water, gradually transitioning to Light pink and Beige. Use *Blue violet pastel* for the shadow of the bridge on the water.

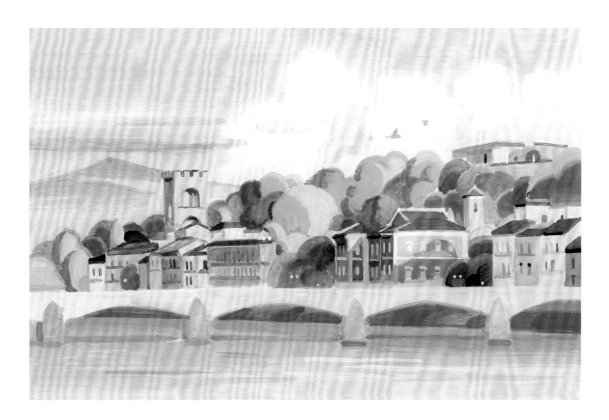

11. Finally, incorporate small details with extra-fine-tip markers, being mindful not to overdo it. Adjust the brightness of areas to increase contrast across the entire artwork.

SUNSET IN THE DOLOMITES

In the vast region of the Dolomite Mountains in Italy, endless breathtaking views await. A short walk from the Lagazuoi Refuge leads to Mount Lagazuoi's summit. There, the setting sun paints vibrant colors across the mountain peaks – a masterpiece that leaves you in awe of nature's artistry.

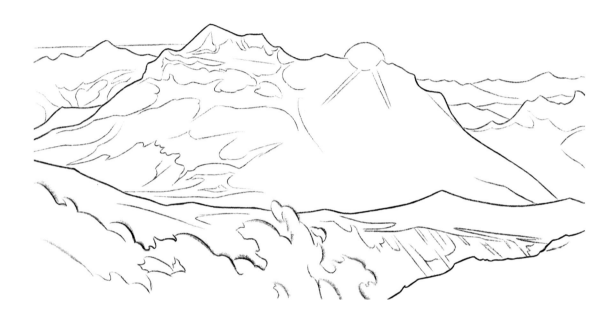

YOU WILL NEED

Markers

Extra-fine tip 0.7mm–1mm
Fine tip 0.9mm–1.3mm
Medium tip 1.8mm–2.5mm
Broad bullet tip 4.5mm–5.5mm

HB pencil
Eraser
Washi tape

Colors (Posca colors in roman, Molotow in italic)

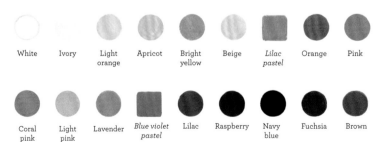

| White | Ivory | Light orange | Apricot | Bright yellow | Beige | *Lilac pastel* | Orange | Pink |

| Coral pink | Light pink | Lavender | *Blue violet pastel* | Lilac | Raspberry | Navy blue | Fuchsia | Brown |

1. Leave the area for the sun empty or fill it with a White marker. Create a radial gradient around it, transitioning from Ivory to Light orange and ending in Apricot. For the mountain in front, which is darker than the sky, blend from Ivory into Apricot and then into Bright yellow.

2. Extend the radial gradient from the sun to the rest of the sky by filling it with Light orange and Apricot. To transition to a cooler color at the top, blend the Apricot into Beige and then introduce *Lilac pastel*.

3. Outline the midground mountain with Orange and Pink markers to create separation. Now work on the background mountains: use Bright yellow and Orange on top, blending to Light orange below. For the mountain closest to the midground, add touches of Pink and Coral pink.

4. Work on the left background mountain layers, which are cooler in tone and farther from the sun. Begin with Light pink as the base, layering Lavender for darker areas. For the ones in front, employ *Blue violet pastel* and Lilac along the edges to enhance definition and separation.

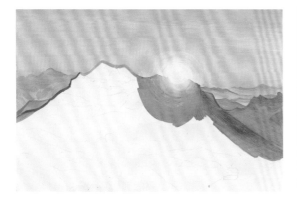 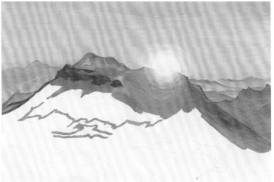

5. Apply Pink and Coral pink to the back mountain on the right, adding Raspberry to darken the top. Work on the midground mountain layer by blending Bright yellow into Coral pink and Pink for the glow. Add Lilac on the right edge to separate it from the background.

6. To depict the ruggedness of the mountain area outside the radial glow, use Lavender, *Blue violet pastel* and Lilac to fill in jagged, spiky shapes. Take your time to define the rough texture of the uncovered mountain area.

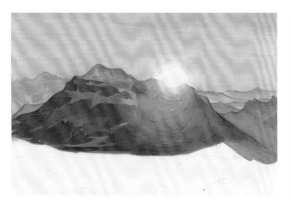 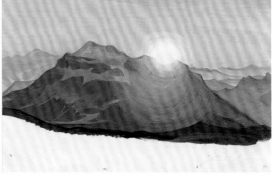

7. Continue detailing the rugged shapes of the mountain using *Blue violet pastel* as the base and Lilac as the shadow. Seamlessly blend these colors into the warm radial glow, creating a harmonious transition between the rugged terrain and the glow from the setting sun.

8. For the foreground terrain, create a darker tone than the midground. Apply Navy blue mixed with Lilac on the left side and transition to Fuchsia mixed with Brown on the right. The shift to warmer colors reflects the sunlight's influence.

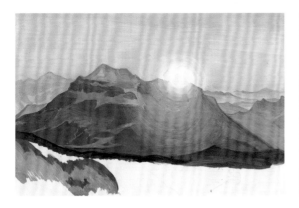 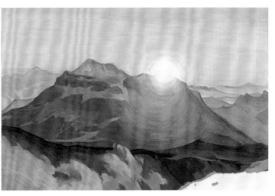

9. Use Lavender, *Blue violet pastel* and Lilac to start depicting the foreground cloud. To recreate the softness of the cloud, soften the edges as much as possible.

10. To finish the cloud, apply Light orange to depict the part illuminated by the sun. Then, use Lilac, Brown and a touch of Navy blue diagonally to depict the terrain behind.

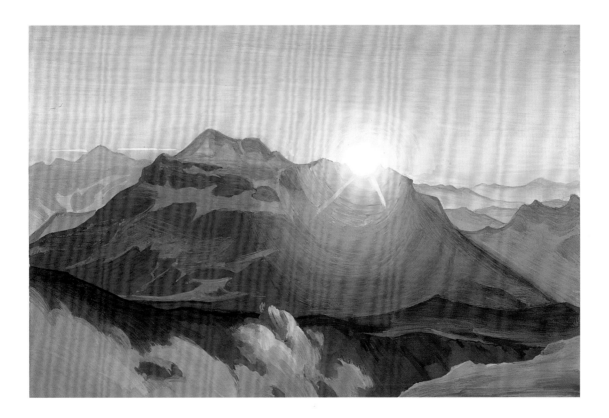

11. Now incorporate small details with extra-fine-tip markers, being mindful not to overdo it. Adjust the brightness of areas to increase contrast across the entire artwork.

SUNRISE IN ZÜRICH

The Lindenhof Hill in Zürich, Switzerland, offers a stunning view of the sunrise. Although the sun is initially blocked by a distant hill at sunrise, it emerges slowly after half an hour. Simplifying this distant hill into a straight line can enhance the composition.

YOU WILL NEED

Markers
Extra-fine tip 0.7mm–1mm
Fine tip 0.9mm–1.3mm
Medium tip 1.8mm–2.5mm
Broad bullet tip 4.5mm–5.5mm

HB pencil
Eraser
Washi tape

Colors (Posca colors in roman, Molotow in italic)

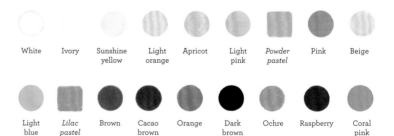

| White | Ivory | Sunshine yellow | Light orange | Apricot | Light pink | *Powder pastel* | Pink | Beige |

| Light blue | *Lilac pastel* | Brown | Cacao brown | Orange | Dark brown | Ochre | Raspberry | Coral pink |

1. Leave the area of the sun blank or fill it with a White marker if necessary. Create a radial gradient around it with Ivory shifting to Sunshine yellow and ending in Light orange. The sun's glow affects the hill in front; use Sunshine yellow and Apricot to show the glow spreading into the hill.

2. Extend the gradient on the hill near the horizon by blending Apricot outward into cooler tones like Light pink, *Powder pastel* and Pink. Start with warmer colors near the sun and gradually transition to cooler pink shades for the less illuminated areas.

3. Fill the sky using a broad bullet-tip Light orange marker. Now introduce condensation trails using Sunshine yellow and Ivory to add interest and dynamic elements to the otherwise empty space.

4. The building right under the sun in the composition will be framed by the trees behind it, making it the focal point. Fill the wall using Beige and an off-white tone formed by mixing a touch of Light blue into White. Add details on top using *Powder pastel* and *Lilac pastel*.

5. Outline the roofs of all foreground houses with extra-fine-tip Brown and medium-tip Cacao brown markers, using the extra-fine tip Brown marker for distant and smaller shapes. Now use Light pink, *Lilac pastel* and *Powder pastel* to outline the walls and chimneys.

6. Blend Orange into Brown for roofs closest to the rising sun's glow. For roofs farther away, transition from Brown to Cacao brown. Darken outlines with Dark brown for roofs in shadow, ensuring a seamless transition between all the colors.

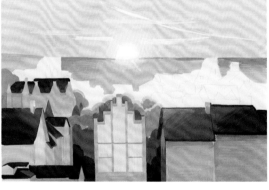

7. Lit by the warm sunlight, the trees behind appear warmer and lighter as they recede. Layer rounded foliage shapes from front to back using Dark brown, Cacao brown, Brown and Ochre. Finally, use a fine-tip Apricot marker to add a rim of light to the back layers.

8. Now let's work on the midground building and tree shapes. Use *Powder pastel* for the wall color; for the roof, blend Pink into Raspberry as it gets darker. For the foliage, incorporate Coral pink and Light orange to add vibrancy to the trees.

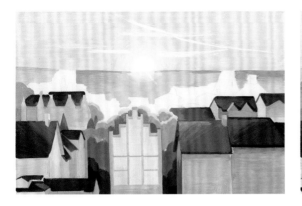 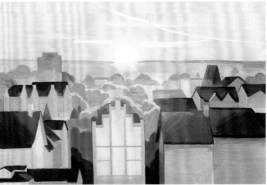

9. Finish the other midground buildings using Brown, Cacao brown, Raspberry and Dark brown for roofs, and *Powder pastel*, Light pink and Pink for walls. Apply warmer tones to areas closer to the sun.

10. Fill in the background shapes of buildings and trees using warm gradients of Light orange to Orange and Light pink to Coral pink and Pink.

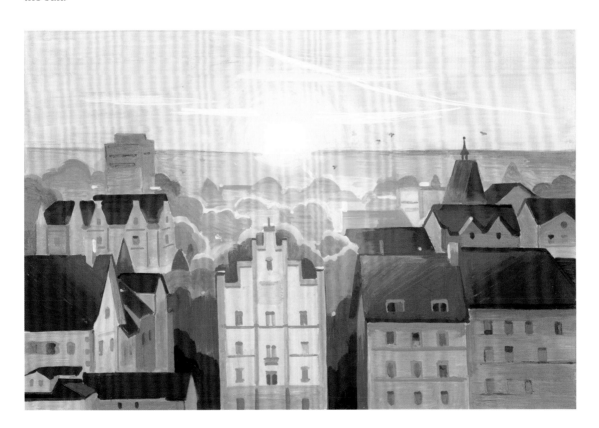

11. Add windows with Pink and Brown in the foreground buildings with slightly more detail and reduce the details for the midground and background. Add Pink birds and dots of Ivory highlight to bring life to the scene.

BRITISH INN

An inn is a traditional British establishment providing accommodations, food and drink to travelers as well as local residents. British inns are typically located in picturesque settings like quaint villages, rolling countryside or near historic sites, adding to their charm.

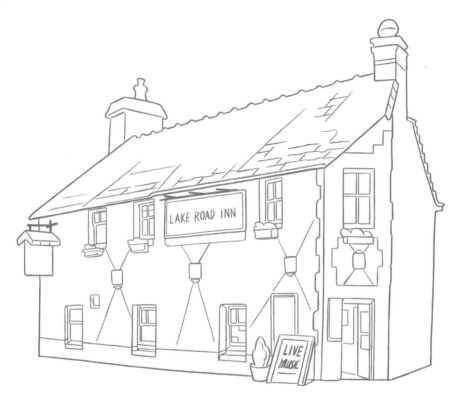

YOU WILL NEED

Markers

Extra-fine tip 0.7mm–1mm

Fine tip 0.9mm–1.3mm

Medium tip 1.8mm–2.5mm

Broad bullet tip 4.5mm–5.5mm

HB pencil

Eraser

Washi tape

Colours (Posca colours in roman, Molotow in italic)

White	Ivory	Light orange	Light pink	Lavender	Sky blue	Navy blue	Light blue	Pink	Violet

Coral pink	Apricot	Ochre	Brown	Cacao brown	Dark brown	Green	English green	Emerald green	Slate gray	Black

1.

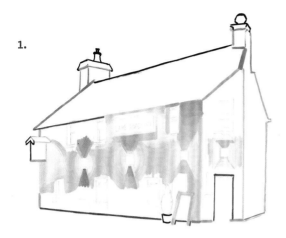

1. Begin with the illuminated wall areas around the light source. Fill the lamps with White and paint the glow with Ivory blending into Light orange and Light pink. Use Lavender for the shadows cast from the top and bottom of the lamp cover. Trace the inn's outline with Sky blue, Lavender and Navy blue fine-tip markers.

2. Continue filling in the rest of the front wall with gradients of Light pink and Lavender, adding a bit of Sky blue to the top left as it gets farther away from the lights. Use Light blue and Sky blue for the chimneys and the right wall, reflecting the blue hour lighting effect in areas not directly lit up.

2.

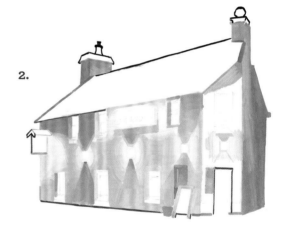

3.

3. Once the base layer of wall color is complete, it's time to add the darker wall areas and overlapping details. For the pink wall, use Pink as the base color, mixing in Violet for darker areas and Coral pink for highlights. Additionally, use Lavender and Apricot for the sign hanging on the left side.

4.

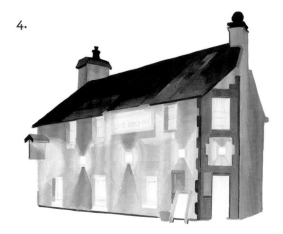

4. Mix a bit of Sky blue into Navy blue, and use this mixture to fill in the dark tops of the chimneys. For the rooftop, begin with a layer of Sky blue near the lower half, gradually blending it into Navy blue toward the top. Then, use Navy blue to block in rectangular shapes that suggest roof tiles in shadow.

5. Begin blocking in the interior of the inn seen through the windows. Use a medium-tip Ivory marker to lay down a base, then add Apricot and Ochre for the first layer of shapes. Add darker details with Brown and Cacao brown markers. Use a Dark brown marker for the entrance door.

5.

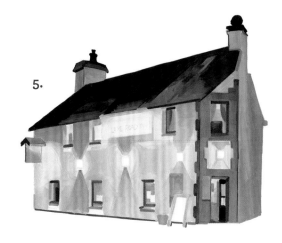

6.

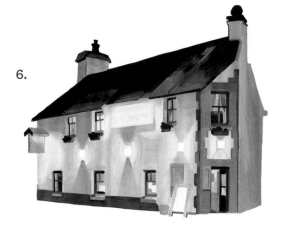

6. Use medium-tip Brown and Cacao brown markers for window frames and hanging planters in front of the windows. Add rounded shapes with Green and English green markers to indicate plants. Finally, use a medium-tip Violet marker for a dark stripe of paint at the bottom of the wall.

7. Add elements like a potted plant using Emerald green, Slate gray and Navy blue. Create the frame of the sign with Apricot and Coral pink, and use Sky blue mixed with Navy blue for the blackboard. Use Navy blue to cast a shadow on the wall behind. Finally, refine the base layer of the pink sign.

7.

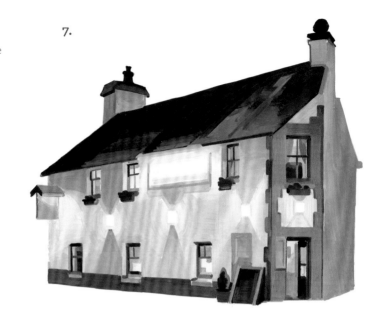

8. Use fine-tip Navy blue and Black markers to add tile details on the roof. Then, with extra-fine-tip White and Pink markers, add lettering on the signs. Finally, detail all the light sources illuminating the inn.

8.

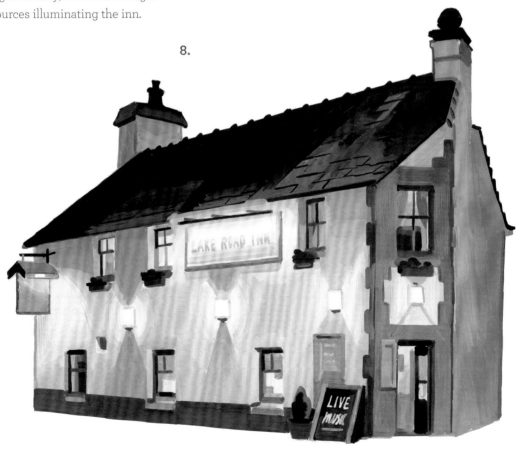

JAPANESE DINER

Japanese traditional diners often have unique architectural elements such as wooden beams, sliding doors, paper screens and traditional roof designs, providing interesting shapes and textures to draw.

YOU WILL NEED

Markers
Extra-fine tip 0.7mm–1mm
Fine tip 0.9mm–1.3mm
Medium tip 1.8mm–2.5mm
Broad bullet tip 4.5mm–5.5mm

HB pencil
Eraser
Washi tape

Colors (Posca colors in roman, Molotow in italic)

White	Ivory	Sunshine yellow	Beige	Apricot	*Powder pastel*	Brown	*Ochre brown light*	Light pink

Red	*Sahara beige pastel*	Coral pink	Cacao brown	Lilac	Dark brown	Navy blue	Lavender	Sky blue	Orange

1.

1. When working on a complex building surface, always start by laying down the base wall color first. For illuminated areas, use a White marker for light shapes and Ivory with Sunshine yellow for the glow. Vary wall colors with Ivory, Beige, Apricot and *Powder pastel.*

2. With Brown and *Ochre brown light* markers, create darker strips of wood framing the walls. Use a medium-tip Apricot marker mixed with Brown for areas of the frame closer to the light source. Incorporate the diner sign using Brown, and fill in posters with White and Light pink markers.

2.

3.

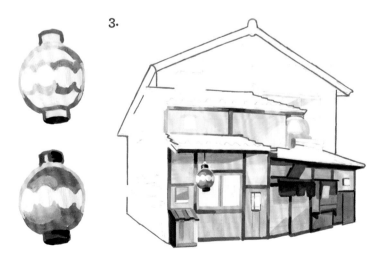

3. Now we'll add a few details to the scene. Outline a lantern with extra-fine-tip Red, Light pink and Brown markers. Now fill in and blend the colors using medium-tip markers. Cover the bottom-left portion of the wall with *Sahara beige pastel.* Create cast shadows on the walls using *Powder pastel*, Coral pink and Apricot.

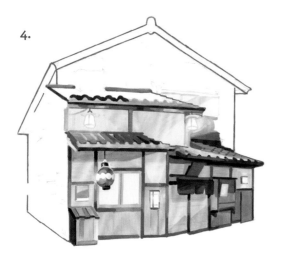

4. The roof tiles are next. For tiles illuminated by warm lights, use warm colors like Beige, Coral pink and Brown, with Cacao brown for shadows. Start by drawing the wavy edges facing the front, then apply the tile color based on their proximity to the lights.

5. Complete the top roof visible from the front using Cacao brown. To cool down the color palette, introduce Lilac to areas not illuminated by lights. Block in the darker parts of the house's structure with Cacao brown, Dark brown, Lilac and Navy blue.

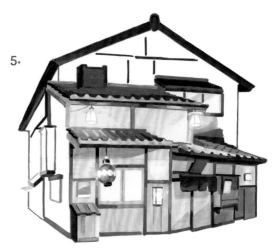

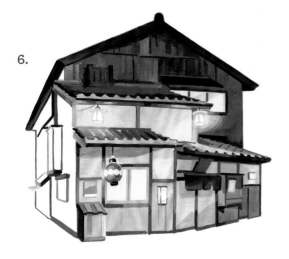

6. Fill in the back wall covered with wooden panels. Begin by using Beige mixed with Brown to depict lighter areas of the wood. Fill in the remaining areas with a medium-tip Brown marker. Afterward, add darker strips of wood using a medium-tip Cacao brown marker.

7. For the side of the diner facing an alleyway not illuminated by warm lights, adjust the colors to create a cooler atmosphere. Use Light pink and Lavender for lighter surfaces, and Sky blue, Lilac and Navy blue for darker details.

7.

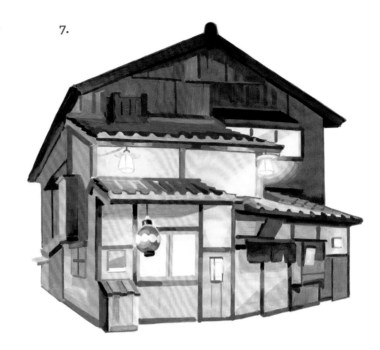

8. Finally, add details to the empty wall spaces. Use fine-tip Apricot, Orange and Brown markers to add lines and thin shapes indicating the carved-in areas of the wood panels and the wall. Additionally, add some lettering on the diner sign to complete the drawing.

8.

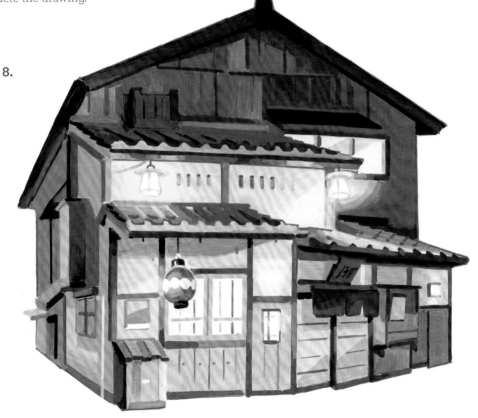

STREET WITH VIEW OF MOUNT FUJI

This view captures the essence of Fujiyoshida, a quaint Japanese city remarkably close to the serene Lake Kawaguchi. The city offers some epic views of Mount Fuji in which the traditional street contrasts with the grand mountain. In this scene, the directional cast shadow of the building leads the viewer's eye to the center of the picture, where an eye-catching sign with kanji writing makes the perfect focal point. Yet Mount Fuji in the background is just as important and deserves as much attention to detail in its depiction.

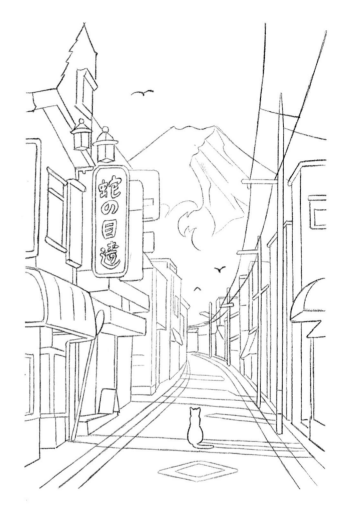

YOU WILL NEED

Markers

Extra-fine tip 0.7mm–1mm
Fine tip 0.9mm–1.3mm
Medium tip 1.8mm–2.5mm
Broad bullet tip 4.5mm–5.5mm

HB pencil
Eraser
Washi tape

Colors (Posca colors in roman, Molotow in italic)

| Lilac | Lavender | *Powder pastel* | Light pink | Aqua green | *Blue violet pastel* | Violet | Emerald green | Navy blue |

| Black | Light blue | Ivory | Beige | White | Light orange | *Lilac pastel* |

1. Begin with the focal point. Outline the houses using fine-tip markers in various shades of purple, such as Lilac and Lavender. Use *Powder pastel* for the lighter surfaces.

2. Add main colors with *Powder pastel*, Light pink, Lavender and Aqua green. Add cast shadow with *Blue violet pastel* and darker shapes in Violet, Emerald green, Navy blue and Black.

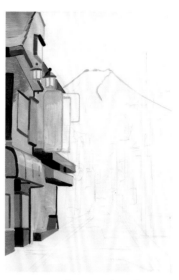

3. Use *Powder pastel*, Light pink and Light blue to outline different sections of Mount Fuji, considering that the light is coming from the left.

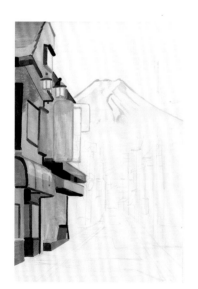

4. Fill highlights with Ivory and add streaks of Beige for texture. Use a broad bullet-tip marker in White mixed with a touch of Light blue for snow on the right.

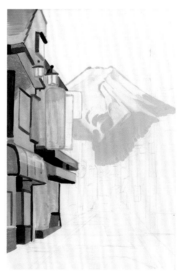

5. Use medium-tip Light blue markers to draw in the rest of Mount Fuji. Simplify any complex shapes.

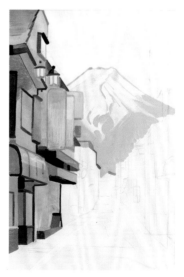

6. Work on the roofs of back buildings with Lavender, *Blue violet pastel* and Lilac. Use Ivory, Light orange, Beige and Aqua green for the signs.

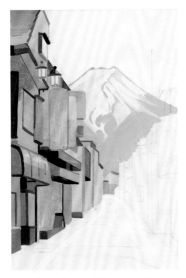

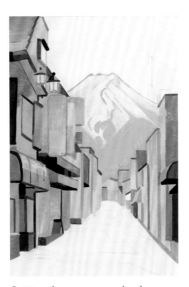

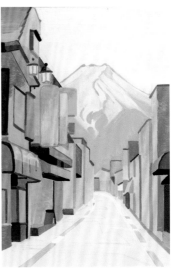

7. Fill in the buildings at the back using Light pink, Beige, *Powder pastel* and *Lilac pastel*.

8. Use the same method as Steps 6 and 7 to work on the right side of the street. Think in terms of value when choosing colors.

9. Add Ivory to the sky. Add markings on the road, using medium-tip White for areas in light and Light pink for areas in shadow.

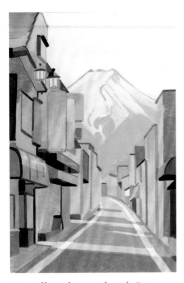

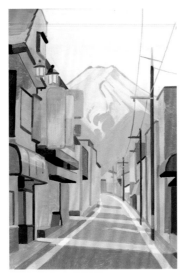

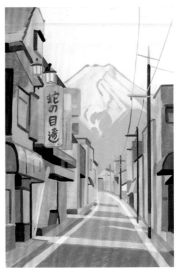

10. Fill in the road with Beige for areas that are in the light; use *Lilac pastel* and *Blue violet pastel* for shadow. Blur the edges with *Powder pastel*.

11. Use fine-tip Lilac and Violet to draw utility poles receding in size following perspective. Add wires with extra-fine-tip Light blue.

12. Add overlaying detail, adjust the darkness of lettering to avoid its being too noticeable, and add small details to fill empty areas.

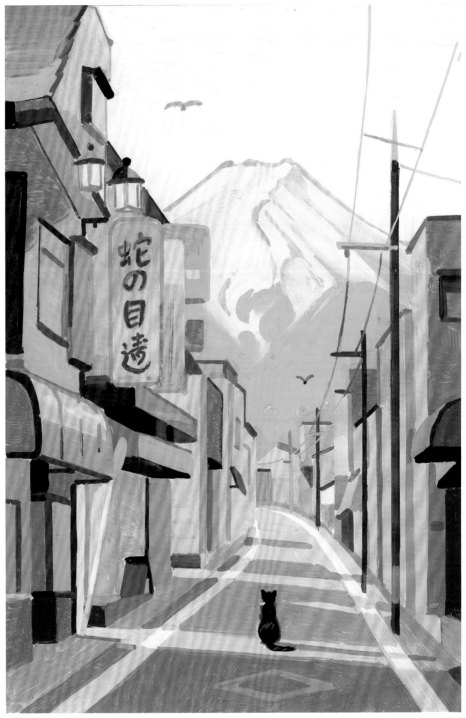

13. Consider adding small characters in strategic places. These characters should be insignificant and placed carefully to avoid cluttering the background.

JAPANESE GARDEN AT NIGHT

Every spring along the Shinobazu Pond in Ueno Park in Tokyo, a row of cherry blossom trees is lit up at night. In the center is a Buddhist temple illuminated by countless spotlights, making it the focal point of this composition. Drawing cherry blossom trees can be very complex. Too many unnecessary details are distracting, so simplifying the trees into easy-to-read silhouettes is important. Another major aspect of this composition is the reflections in the water, made by using medium-tip markers to draw vertical streaks of color.

YOU WILL NEED

Markers

Extra-fine tip 0.7mm–1mm

Fine tip 0.9mm–1.3mm

Medium tip 1.8mm–2.5mm

Broad bullet tip 4.5mm–5.5mm

Broad chisel tip 5.5–8mm

HB pencil

Eraser

Washi tape

Colors (Posca colors in roman, Molotow in italic)

 Orange

 Sunshine yellow

 Brown

 Light pink

 Light orange

 Dark brown

 Emerald green

 Apricot

 Lavender

 Lilac

 Sky blue

 Ivory

 Aqua green

 Turquoise

 White

 Lilac pastel

 Violet

 Green

 Navy blue

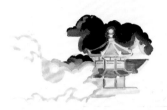

1. Use an extra-fine-tip marker in Orange to outline the temple, and fill it in with Sunshine yellow and Orange.

2. Work on the immediate surrounding area with Orange and Brown. Outline the shape of the cherry blossom trees with Light Pink. Circle the light behind the trees with Light Orange.

3. Use Brown and Dark brown for the background foliage, adding a touch of Emerald Green for the areas facing the sky.

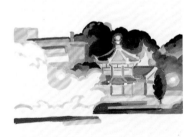

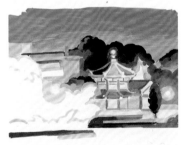

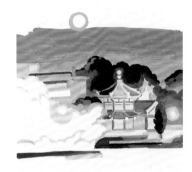

4. Continue refining the surrounding area. Blend Apricot into Brown, with Dark brown for shadow on the right, and Light pink, Lavender and Lilac on the building to the left.

5. Use a medium-tip Lavender marker to carefully trace out and fill in the bottom of the sky, then blend it immediately into Sky blue.

6. Fill in the moon with Ivory and outline it in Aqua green.

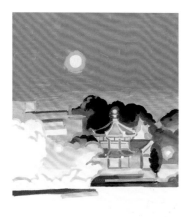

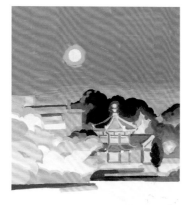

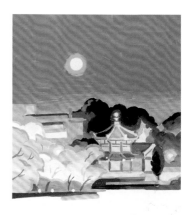

7. Fill in the rest of the sky with either a medium-tip Sky blue marker or, to save time, blend and fill in with a broad chisel-tip Turquoise marker.

8. Now start on the trees, using White, Light pink and *Lilac pastel* to create different shades of pink for the cherry blossom.

9. Use Light pink and Violet extra-fine-tip markers to add tree branches. Use a White marker to add lights beneath the trees.

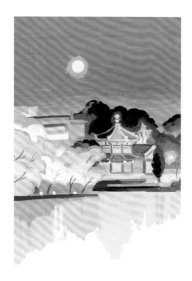

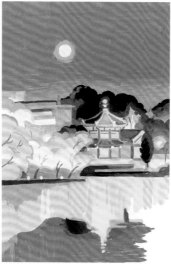

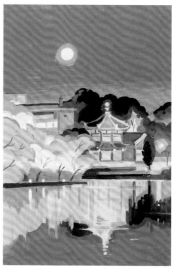

10. Draw the reflection using Sunshine yellow, Light orange, Light pink and Lavender with vertical strokes.

11. Use Turquoise, Emerald green, Green and Navy blue to depict the darker areas of the reflection.

12. Add vertical and horizontal details with Apricot into the reflection.

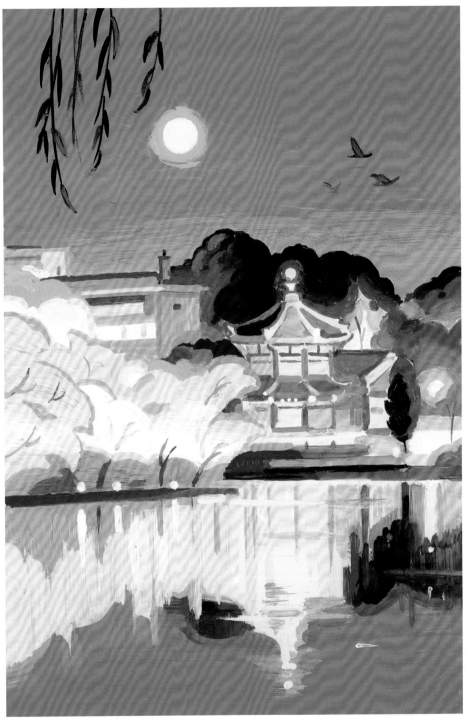

13. Complete the drawing by adding birds in the sky to add interest to the empty space. Refine the cherry blossom trees and temple to enhance their appearance.

CHURCH IN THE DOLOMITES

Located in the Italian Dolomites, the San Giovanni church in Val di Funes is itself picturesque, yet it is the backdrop of forest and rugged mountains that makes this location so captivating. The strikingly simple composition is appealing because of its strong foreground, midground and background, which all harmonize seamlessly. The graceful curves of the forest seem to guide the viewer's gaze downward, toward the church, accentuating its dramatic position.

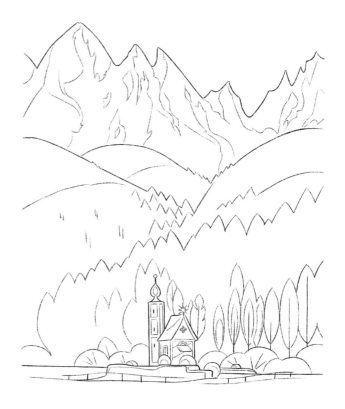

YOU WILL NEED

Markers

Extra-fine tip 0.7mm–1mm

Fine tip 0.9mm–1.3mm

Medium tip 1.8mm–2.5mm

Broad bullet tip 4.5mm–5.5mm

HB pencil

Eraser

Washi tape

Colors (Posca colors in roman, Molotow in italic)

White	Ivory	Light pink	Lavender	Lilac	Sunshine yellow	Light green	Slate gray	Brown	
Straw yellow	Green	Aqua green	Emerald green	Light orange	Light blue	Navy blue	*True blue*	*Powder pastel*	Beige

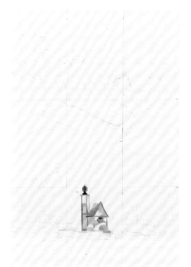

1. Apply White, Ivory and Light pink for the walls of the church, and use Lavender and Lilac for the darker surfaces. Use Sunshine yellow and Light green for small foliage shapes.

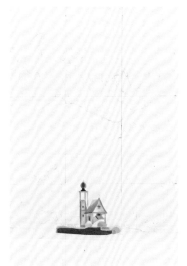

2. Use a Lilac marker to add dark window details. Use Slate gray with a touch of Brown for the shadowed fence.

3. Mix Light green with Straw yellow for bright green grass. Add Sunshine yellow for highlights. Add shadow in Green.

4. Draw the trees and bushes behind the church with Aqua green and Emerald green to create contrast. Use Light green to add highlights.

5. Mix Straw yellow with Light green for the illuminated hills, adding Light orange for the less green areas.

6. Draw tree shapes using Light blue, Aqua green, Green and Emerald green. Apply Green shadows on the Light green.

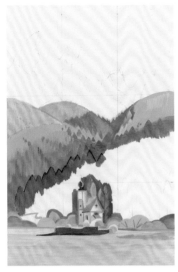

7. Add Emerald green and Green for darker trees, and use a fine-tip Navy blue marker to make the layers look separate.

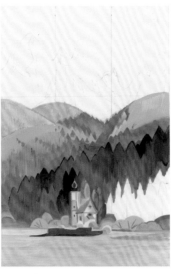

8. Add dark tree shapes in Navy blue behind the church. Blend Navy blue vertically into Emerald green with hints of Green and *True blue* to suggest tonal difference.

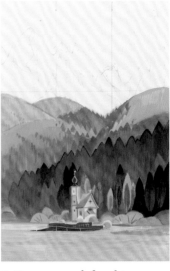

9. Draw more defined tree shapes, incorporating Light green and Aqua green. Use extra-fine-tip White and Light blue to draw a wire fence in front of the stone wall.

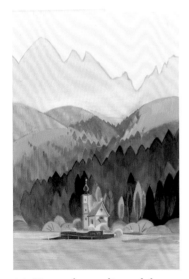

10. Trace the outline of the background mountain using *Powder pastel* and fill it in with Ivory.

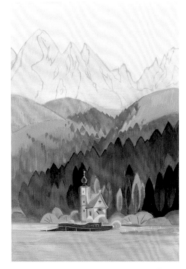

11. Use *Powder pastel* to define the edges of the shadow on the mountain surface.

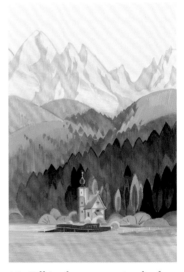

12. Fill in the mountain shadow shapes using a mix of *Powder pastel* and Beige, creating darker edges and lighter centers.

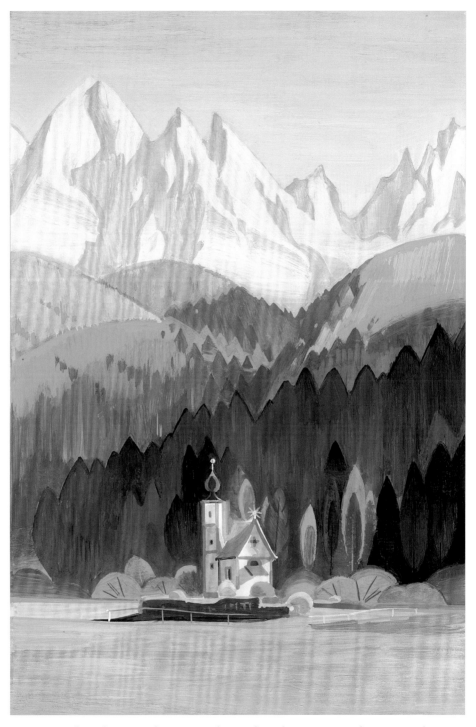

13. To complete the artwork, create a sky gradient by starting with Ivory, applying a layer of White using a broad bullet-tip marker, and blending it horizontally into Light blue.

GOLDEN HOUR IN MILAN

Italy boasts some of the world's most stunning churches, including the famous Milan Cathedral. Strolling through Milan reveals numerous smaller, yet equally beautiful churches. Visiting the city in winter holds a particular charm. At the golden hour, the elaborate silhouettes of bare tree branches create intricate and captivating shadows on the warmly lit walls of Milan's streets. While churches are usually suited for horizontal compositions, just before sunset the rising moon lends extra interest to the sky. Adding a character strolling in front of the church further enhances the scene.

YOU WILL NEED

Markers

Extra-fine tip 0.7mm–1mm

Fine tip 0.9mm–1.3mm

Medium tip 1.8mm–2.5mm

Broad bullet tip 4.5mm–5.5mm

HB pencil

Eraser

Washi tape

Colors (Posca colors in roman, Molotow in italic)

| Ivory | Bright yellow | Apricot | Brown | Beige | Dark brown | White | Light blue | Light pink | Orange |

Powder pastel | *Ochre brown light* | *Vanilla pastel* | Violet | Light orange | *Lilac pastel* | Lavender | Black | *Blue violet pastel*

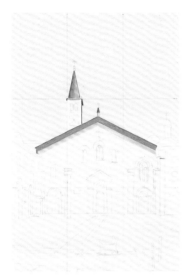

1. Use Ivory for the tower's light edge, then Bright yellow, Apricot and Brown for edges touching the sky.

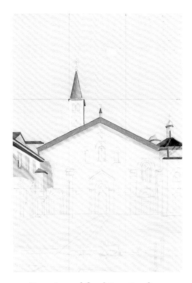

2. Continue blocking in the upper church section with fine-tip Ivory, Beige, Brown and Dark brown markers.

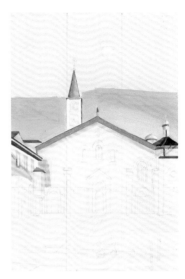

3. Blend White and Light blue broad bullet-tip markers to create a lighter sky area where it will touch the Bright yellow and Apricot edges of the tower.

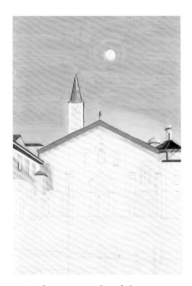

4. Soften one side of the moon with a White marker, blending it into Light blue. Fill in the sky with a Light blue broad bullet-tip marker, in a horizontal motion.

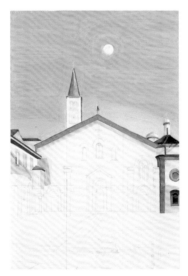

5. Apply Ivory, Beige and Light pink for the walls, then add Orange and Brown for the window details on top. Darken details in shadow with Dark brown.

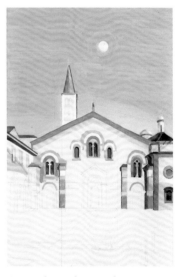

6. Work on the windows, ensuring symmetry. Use Ivory as the base, and add Bright yellow on top to outline the window frames.

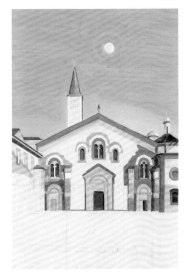

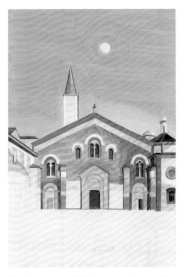

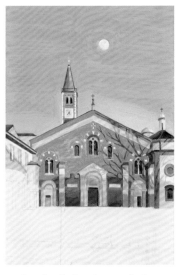

7. Use Beige, *Powder pastel* and Light pink for doorways. Apply Bright yellow to walls and *Ochre brown light* with a hint of Brown for shadows.

8. Continue filling in the wall color. Mix *Vanilla pastel* with Bright yellow to brighten the left side.

9. Apply *Ochre brown light* on Bright yellow and *Powder pastel* on Beige to create cast shadows on the wall, and add details to the clock tower with extra-fine-tip markers.

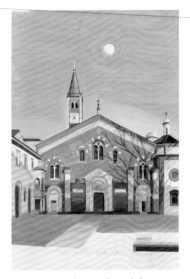

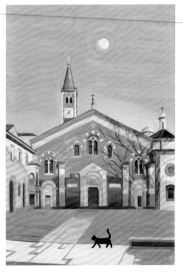

10. Use Violet and Dark brown to add the doors on the left. Add Light orange for warm reflected light on the ground, blended into *Lilac pastel* and Lavender.

11. Add the cat using Black with Brown highlights and carefully work around it, using a Lavender marker to outline the pavement.

12. Fill in darker blocks of the pavement with *Blue violet pastel* and *Lilac pastel*. Add dark details with Violet.

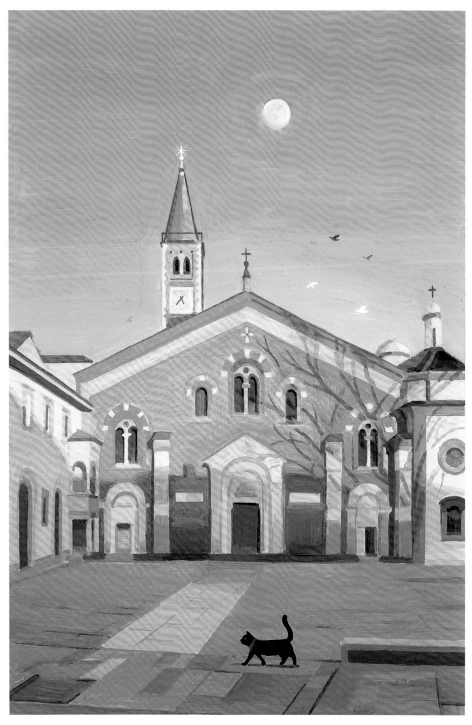

15. Use an extra-fine-tip marker to detail the White tip of the church tower. With darker extra-fine-tip markers, add small birds flying toward the church tower.

LEANING BELL TOWER IN VENICE

Venice is renowned as one of the world's most beautiful cities, celebrated for its complex network of canals adorned by vibrant houses that grace their banks. It's an artist's paradise, offering limitless potential for intriguing compositions. The bell tower, or *campanile*, of San Giorgio dei Greci is one of Venice's three leaning bell towers, and it's the one that catches my attention the most. Its slight lean adds an intriguing element to the repetitive vertical lines of the houses and their reflections in the canals. During the golden hour, it bathes in the warm, low-angled sunlight, casting a mesmerizing glow against the blue sky.

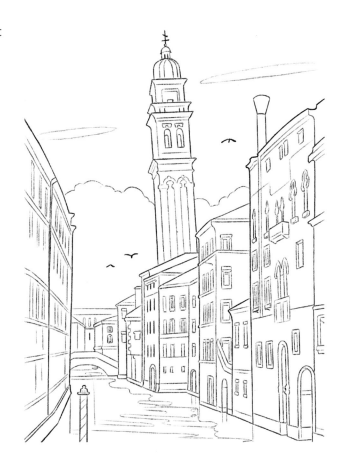

YOU WILL NEED

Markers
Extra-fine tip 0.7mm–1mm
Fine tip 0.9mm–1.3mm
Medium tip 1.8mm–2.5mm
Broad bullet tip 4.5mm–5.5mm

HB pencil
Eraser
Washi tape

Colors (Posca colors in roman, Molotow in italic)

Powder pastel Brown Ivory Beige *Lilac pastel* Lavender Light pink Orange Light orange

Sunshine yellow *Lobster* Coral pink Dark brown *Sahara beige pastel* Apricot Pink Light blue Gray

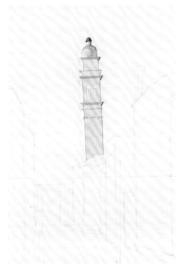

1. Use *Powder pastel* and Brown to outline the tower; fill in with Ivory and Beige. Add shadow with *Lilac pastel* on the dome top.

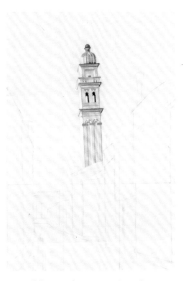

2. Add *Powder pastel* and Brown details to the tower. Use Lavender and Light pink for the shadowed dome.

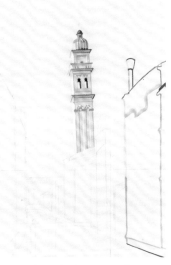

3. Outline the house in front using Orange and *Powder pastel*. Use Light orange for the edge of the cast shadow.

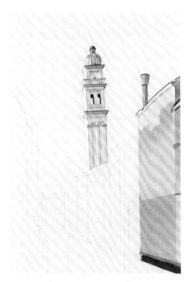

4. Apply Sunshine yellow to the illuminated wall, and use Apricot, Beige and *Powder pastel* for the cast shadow.

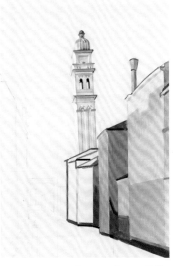

5. Draw in roofs in *Lobster*. Fill in walls with Apricot, Coral pink and Brown. Use Dark brown to add shadows.

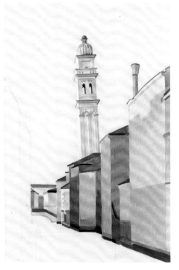

6. Continue filling in walls with Apricot, *Powder pastel*, Coral pink and Orange. Use Ivory, Light orange and *Sahara beige pastel* for the walls of the back houses, and Brown for the roofs.

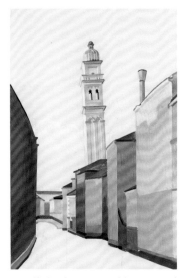

7. Fill the foreground house with darker tones such as Orange and Brown, with Dark brown for the edges.

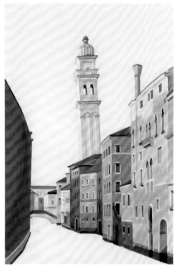

8. Outline the windows with Ivory, Light pink and Beige to accentuate the darker interiors that are in Pink, Brown and Dark Brown.

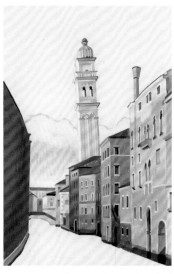

9. Use Sunshine yellow blended with Ivory for the lit part of the cloud, and Beige with *Powder pastel* for shadowing.

10. Outline the cloud with Light orange before creating a gradient from Light orange to Light pink in the sky.

11. Blend Light pink into *Lilac pastel*, then transition it into Light blue across the sky. Add thin horizontal clouds.

12. Draw the water's reflection horizontally in Brown, with vertical Dark brown shadows, desaturating the Brown tones with Gray.

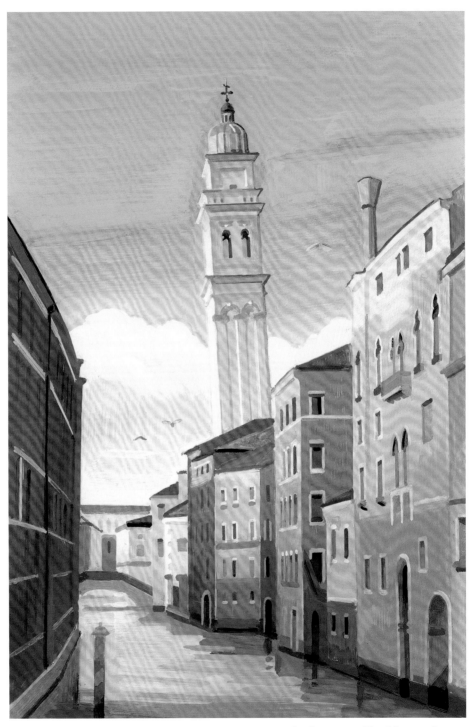

15. To finish, incorporate windows in perspective on the foreground building with Brown and Dark brown. Add Light pink strokes for lighter details on the wall. Introduce birds diminishing in size to enhance depth within the composition.

AFTERNOON IN COIMBRA

Coimbra, a university city in Portugal, is renowned for its enchanting fado music. Its narrow medieval streets invite exploration, promising surprises at every turn. From hilltop vistas to ancient alleyways, Coimbra captivates all who visit. Among my favorite sights are the layers of houses at the ends of these narrow lanes. The buildings are adorned with charming street lamps and colorful windows that recede in size due to perspective, guiding our gaze toward the distant backdrop of houses. This interplay of elements creates an artistic scene that feels alive, drawing us deeper into the heart of the city.

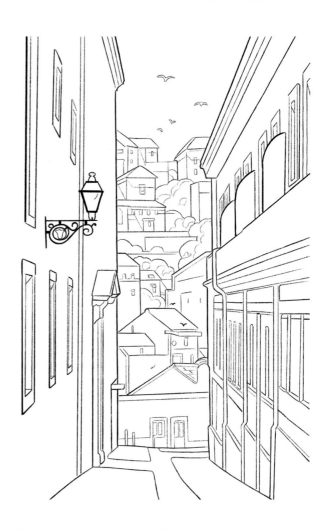

YOU WILL NEED

Markers
Extra-fine tip 0.7mm–1mm
Fine tip 0.9mm–1.3mm
Medium tip 1.8mm–2.5mm
Broad bullet tip 4.5mm–5.5mm

HB pencil
Eraser
Washi tape

Colors (Posca colors in roman, Molotow in italic)

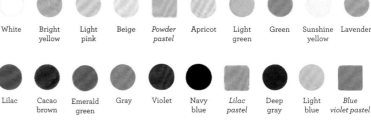

White	Bright yellow	Light pink	Beige	*Powder pastel*	Apricot	Light green	Green	Sunshine yellow	Lavender

Lilac	Cacao brown	Emerald green	Gray	Violet	Navy blue	*Lilac pastel*	Deep gray	Light blue	*Blue violet pastel*

Pink	Fuchsia	Black

1. Use White for lit-up walls and Bright yellow for roofs. Use Light pink with Beige and *Powder pastel* with Apricot for walls in shadow.

2. Add foliage behind the houses using Light green and Green. Add Sunshine yellow to back foliage shapes.

3. Use Light pink and Beige as shadows on White walls. Add Beige to Light green for faded foliage at the back. Add Apricot to Bright yellow for distant roofs.

4. Outline the edges of the foreground buildings with Lavender, Lilac and Cacao brown.

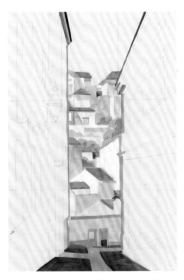

5. Use Lavender for the pathway and incorporate Emerald green and Gray into Violet for the darker pavement.

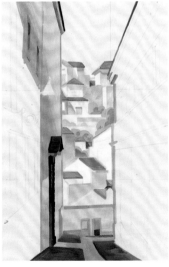

6. Blend Beige into Light pink and then into *Lilac pastel* as a base for the foreground left wall. Use Lilac, Violet and Deep gray for the doorway.

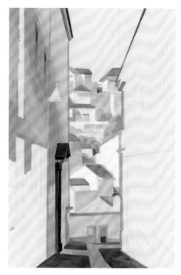

7. For the left wall, blend Light blue and Lavender into *Lilac pastel*, leaving the window areas empty for now.

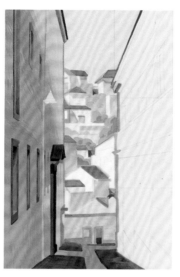

8. Finish blending the wall into Light blue, and add windows with *Blue violet pastel*, Lilac and Violet.

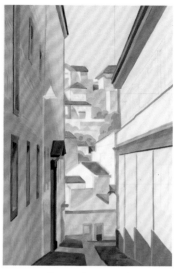

9. Use *Blue violet pastel* and Lavender for the other wall. Mix Emerald green and Gray for the window ledges' shadow side.

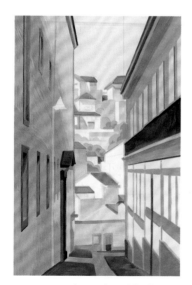

10. Use Light pink to block in the top window frames, with shadow in Lilac. Fill in the dark balcony area with Violet and Navy blue. Outline the bottom with Lavender and Gray.

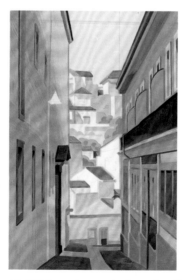

11. Fill in with a variation of wall color using Lavender, Pink and Fuchsia. Define the windows with Lilac and Violet.

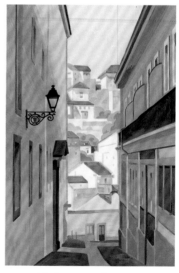

12. Add the street lamp using an extra-fine-tip Black marker. Mix in Navy blue for variation, along with Lilac.

13. To refine the drawing, use *Blue violet pastel* to indicate stones on the pebbled street, and use an extra-fine-tip White marker to add birds.

BASILIQUE DE VALÈRE IN SION

Sion, though less renowned than some other Swiss cities, holds immense historical significance as one of Europe's major prehistoric sites. Among its iconic vistas, the Basilique de Valère and the Château de Tourbillon stand atop hills, framed by the grandeur of the Swiss Alps. In a vertical composition, either of these landmarks would claim center stage. Here, the Basilique de Valère is adorned with spotlights encircling the castle, illuminating its walls delightfully. The warm glow they lend the castle walls creates a captivating contrast against the deep-blue backdrop of the mountains during the serene blue hour.

YOU WILL NEED

Markers

Extra-fine tip 0.7mm–1mm
Fine tip 0.9mm–1.3mm
Medium tip 1.8mm–2.5mm
Broad bullet tip 4.5mm–5.5mm
Broad chisel tip 5.5.mm–8mm

HB pencil
Eraser
Washi tape

Colors (Posca colors in roman, Molotow in italic)

Navy blue *Shock blue* Sunshine yellow Apricot *Powder pastel* Lavender Pink Brown Violet Sky blue Light blue

Ivory Beige Turquoise Light green Green Emerald green Light pink *Lilac pastel* Light orange *Blue violet pastel* Slate gray Orange

1. Begin with the castle roof, using Navy blue and *Shock blue*. Start blocking in the lit-up area using Sunshine yellow, Apricot, *Powder pastel* and Lavender.

2. Add shadowed walls with Pink, Brown and Violet, and using Sunshine yellow for contrast. Use Sky blue and Light blue to fill in the area of the mountain behind.

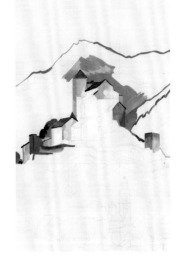

3. Outline the mountains in Sky blue and *Shock blue*. Continue building up the scene, adding Ivory and Beige for lit-up walls, and Violet and Navy blue for roofs.

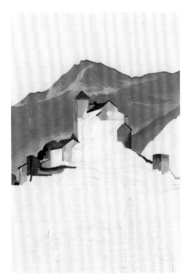

4. Use Light blue to fill in the bottom of the mountain behind the castle, blended into Sky blue. Leave out areas of Light blue to depict the texture on the mountain.

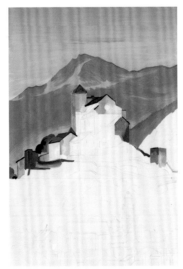

5. Fill in the sky using broad bullet-tip markers, beginning with Light blue at the bottom and blending into Turquoise.

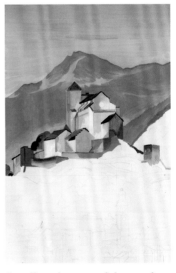

6. Fill in the rest of the castle buildings, paying attention to where the light is falling, repeating the colors from Steps 1–3 for well-lit and shadowed areas.

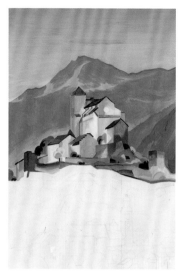

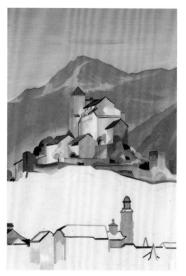

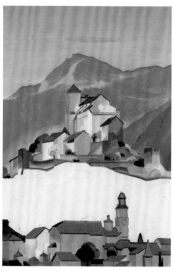

7. Use *Shock blue* and Sky blue for the mountain on the right. Add some foliage with Light green, Green, Emerald green and Navy blue.

8. Outline the foreground houses with Sky blue, *Shock blue* and Navy blue. Fill the walls with Light pink, *Lilac pastel* and Lavender. Use Ivory and Light orange for lit-up walls.

9. Complete the foreground houses by filling their roofs with *Shock blue*, adding Navy blue for shadows. Fill in walls with Lavender and *Blue violet pastel*.

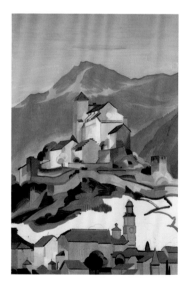

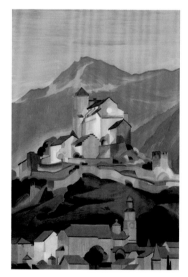

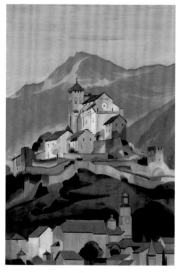

10. Use Emerald green, Slate gray, Turquoise and Navy blue to block in the shadow shapes on the hill.

11. Soften the shadow and darken the bottom area with Navy blue to accentuate the foreground houses.

12. Use extra-fine-tip Orange, Brown and Violet markers to add window and roof details to the castle.

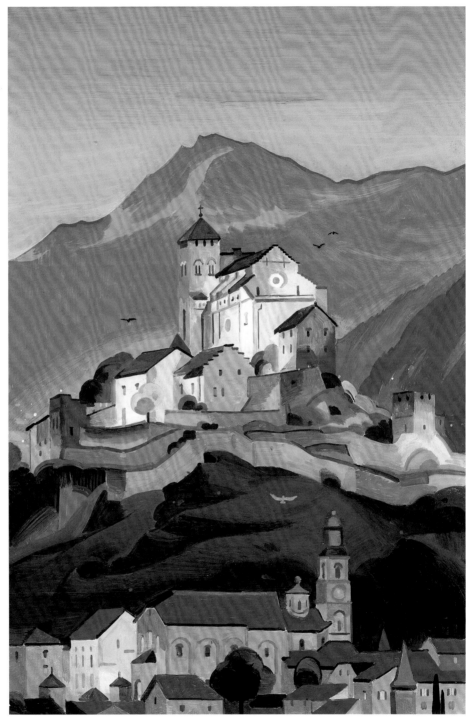

13. Apply *Blue violet pastel*, Violet, Pink and Brown detail to the windows on the foreground houses. Use Sunshine yellow for illuminated window openings. Add birds using fine-tip Navy blue and Light blue markers.

PORTO CATHEDRAL BEFORE SUNSET

Porto is one of the most stunning places I've ever been to. The city's essence is woven into its cobbled streets, historical neighborhoods, and magnificent landmarks. Porto Cathedral, situated atop a hill, naturally creates a striking focal point in any composition, but during the transition to the golden hour it becomes even more visually captivating. The cathedral's bricks transform from muted tones to a vibrant orange, standing out against the sky. At the same time, the houses in shadow adopt a purplish hue, creating a beautiful contrast with the warmly lit surfaces facing the sun.

YOU WILL NEED

Markers

Extra-fine tip 0.7mm–1mm

Fine tip 0.9mm–1.3mm

Medium tip 1.8mm–2.5mm

Broad bullet tip 4.5mm–5.5mm

HB pencil

Eraser

Washi tape

Colors (Posca colors in roman, Molotow in italic)

| Apricot | Ivory | Sunshine yellow | Orange | Ochre | Brown | Light pink | Beige | Pink | *Lilac pastel* | *Blue violet pastel* |

| Cacao brown | *Powder pastel* | Lavender | Emerald green | English green | Navy blue | Raspberry | Violet | Gray | Lilac | White |

1. Use Apricot, Ivory and Sunshine yellow for the tower walls. Add Orange and Ochre for shadow definition.

2. Use extra-fine-tip Orange and Brown markers for detailing windows, and add highlights with Ivory.

3. Apply Ivory as the base color for the right wall, then add Light pink with a Beige edge to create the cast shadow.

4. Use fine-tip markers in Pink, Orange and Brown to outline the houses' roof shapes in front of the cathedral.

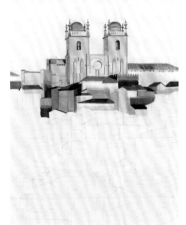

5. Fill in houses with Ivory, Beige and Ochre for light areas; use *Lilac pastel*, *Blue violet pastel*, Brown and Cacao brown for shadows.

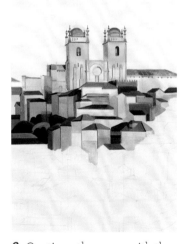

6. Continue the scene with the colors from Step 5, now adding some *Powder pastel*, Lavender and Orange. Add foliage with Emerald green, English green and Navy blue.

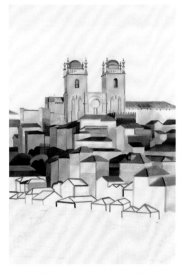

7. Outline the houses with fine-tip and medium-tip Orange and Brown markers.

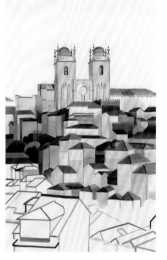

8. Draw the houses with Ivory, Beige and Light pink walls, and add Brown roofs. Outline the foreground.

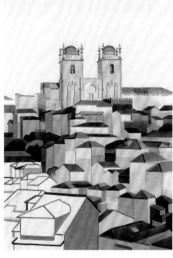

9. Use Lavender and *Blue violet pastel* for the darker foreground houses. Use Brown mixed with Raspberry, Violet and Cacao brown for the rooftops.

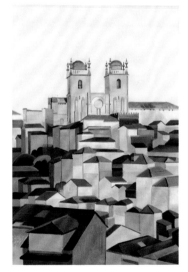

10. Once the foreground is blocked in, add Gray to desaturate the shadowed walls. Use Navy blue to darken any roofs in shadow.

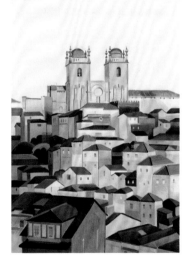

11. Add windows with fine tip markers in Beige, Pink, *Blue violet pastel* and Lilac, choosing either a darker or lighter tone than the base wall color.

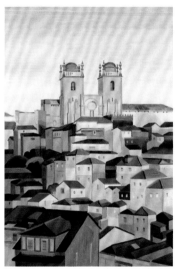

12. Blend Ivory into Beige, shifting to Light pink mixed with *Lilac pastel* for the sky.

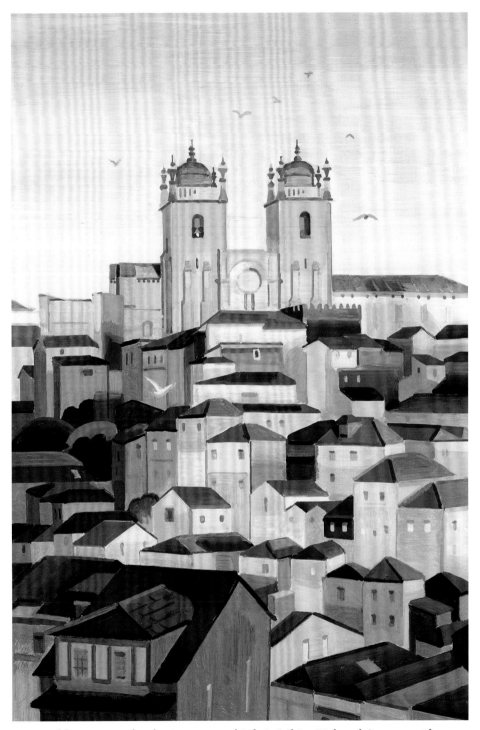

13. To add interest to the sky, incorporate birds in White, Pink and Orange, as if they've just taken off from the cathedral. Include a white bird atop a darker surface closer to us for added depth.

FLORENCE AFTER SUNSET

From Piazzale Michelangelo, not only can we see the breathtaking view of the Cathedral of Santa Maria del Fiore, but just west of it is the tower of Palazzo Vecchio. Called the Torre di Arnolfo, it stands beautifully illuminated by warm lights amid the enchanting blue hour cityscape. Buildings along the Arno river are also illuminated by lights from below. On cloudless days, faint mountain ranges unveil themselves in the distance, lending an added depth and intrigue to the overall composition. Amid this backdrop, distant lights twinkle like stars, scattering a whimsical glow across the serene landscape.

YOU WILL NEED

Markers

Extra-fine tip 0.7mm–1mm

Fine tip 0.9mm–1.3mm

Medium tip 1.8mm–2.5mm

Broad bullet tip 4.5mm–5.5mm

HB pencil

Eraser

Washi tape

Colors (Posca colors in roman, Molotow in italic)

 Light orange
 Orange
 Brown
 Dark Brown
 Ivory
 Lavender
 Lilac
 Violet
 Light pink
 Navy blue

 Light blue
 Sky blue
 Beige
 Powder pastel
 Blue violet pastel
 White

1. Start with the focal point, the midground tower. Define it with Light orange, Orange, Brown and Dark brown. Add Ivory for highlights.

2. Outline surrounding shapes with Lavender, Lilac and Violet. Use Light orange, Orange and Brown for lit-up warm areas.

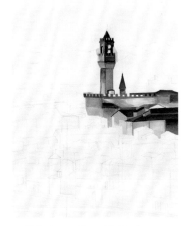

3. Fill the walls with Light orange, Light pink, Lavender and Brown; use Violet and Navy blue for the roofs.

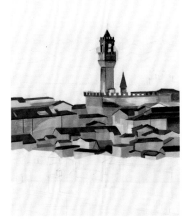

4. Block in midground buildings with Light pink, Lavender and Light blue walls, with Sky blue shadows. Use Lilac, Violet and Navy blue markers for the roofs.

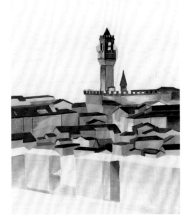

5. Lay down the light wall colors of the foreground buildings with Ivory, Beige, Light pink, *Powder pastel* and Lavender.

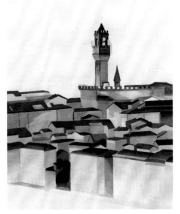

6. Add dark roofs with Violet and Navy blue. Use Orange, Brown, Dark brown and Navy blue for the foliage seen between the buildings.

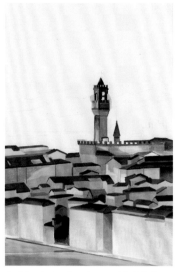

7. Block in the river with Light blue and Sky blue. Trace out and darken the edge with a fine-tip Lilac marker. Use Beige to indicate the bridge in the center.

8. Add simplified windows to the foreground buildings with Lavender, Light orange, Light pink and Ivory.

9. Add windows to midground buildings with Lilac, Violet and Light orange. Add the silhouette of distant buildings using Lavender and Lilac.

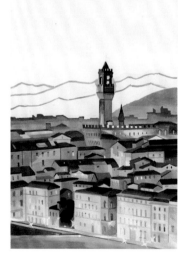

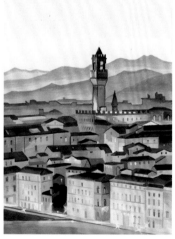

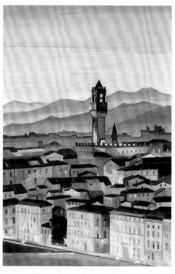

10. Outline and fill in the background hills with *Blue violet pastel* and Lavender.

11. Create the faded distant hills using Lavender and Light pink gradients.

12. Fill in the sky with Ivory, Light orange, Beige and a touch of Lavender at the top.

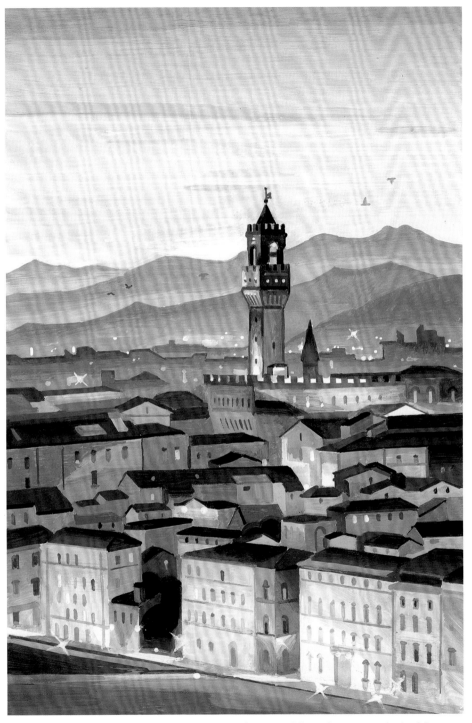

15. Apply White and Ivory extra-fine-tip markers to add sparks among the buildings and distant dots of light. Use Violet and assorted blue extra-fine-tip markers to depict small birds within the scene.

SANTA MARIA DEL FIORE

The best spot to view Florence's duomo, or Cathedral of Santa Maria del Fiore, is from the Piazzale Michelangelo. The white marble of the duomo almost seems to glow in the sunlight, while its roof takes on a warm orange hue. Florence is a city abundant in warm tones, ranging from light yellow walls to brown rooftops, so a warm color palette best captures the essence of the Florentine colors. The mountains surrounding Florence are an important part of its magic. You can use atmospheric perspective to blend distant mountain ranges into the sky's color. Once you've established the color of the sky in a composition by setting the light source, it guides how every other aspect of the scene should be handled.

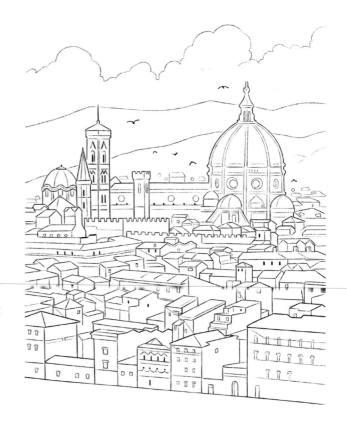

YOU WILL NEED

Markers

Extra-fine tip 0.7mm–1mm
Fine tip 0.9mm–1.3mm
Medium tip 1.8mm–2.5mm
Broad bullet tip 4.5mm–5.5mm

HB pencil
Eraser
Washi tape

Colors (Posca colors in roman, Molotow in italic)

Coral pink · Light pink · Apricot · Orange · Beige · Pink · Ivory · *Lobster* · Lavender · *Powder pastel*

Brown · *Sahara beige pastel* · Dark brown · White · Light orange

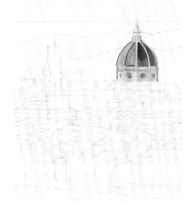

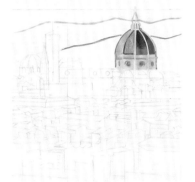

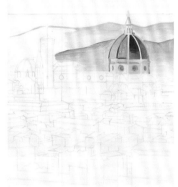

1. Outline the dome with Coral pink and Light pink, then fill in with Apricot, Orange and Coral pink. Use Beige and Light pink for the walls. Add windows with Coral pink and Pink.

2. Use medium tip Light pink and Coral pink markers to contour the edges of the background mountains.

3. Blend the Light pink and Coral pink edges of the background mountains into Beige and Ivory.

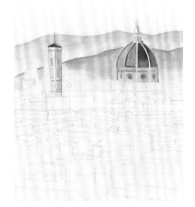

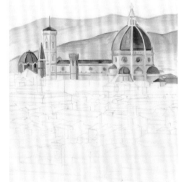

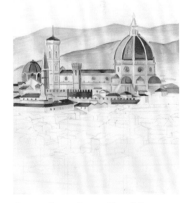

4. Before finishing the background mountains, work on Giotto's Bell Tower using Ivory, Beige and Light pink for the walls, and *Lobster* and Pink for the roof.

5. Complete the cathedral with Lavender shadow on the right. Use Beige, Coral pink and *Powder pastel* for the walls of three overlay structures. Add details in Light pink and Brown.

6. Work on the walls of the palace known as the Bargello and the surrounding houses with Beige, Coral pink, *Lobster* and Brown.

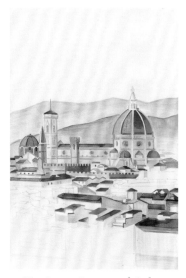

7. Use Ivory, Beige and *Sahara beige pastel* on walls, and Lobster and Brown on roofs. Mix in Pink for variation, and add Dark brown for shadow.

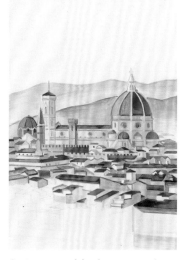

8. Continue blocking in with the colors listed in Step 7. Add Apricot and Coral pink to lighten some of the Brown roofs and lessen the contrast.

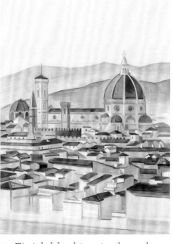

9. Finish blocking in the colors, and add White to brighten some of the foreground walls.

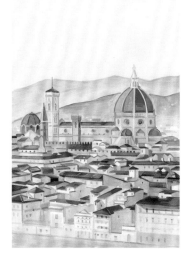

10. Add light-colored windows on all buildings with *Powder pastel*, Pink and Brown.

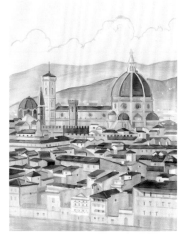

11. Use a fine-tip marker in Light orange to outline the rounded cloud shape.

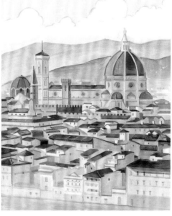

12. Create a faint gradient in the clouds, transitioning from White to Ivory.

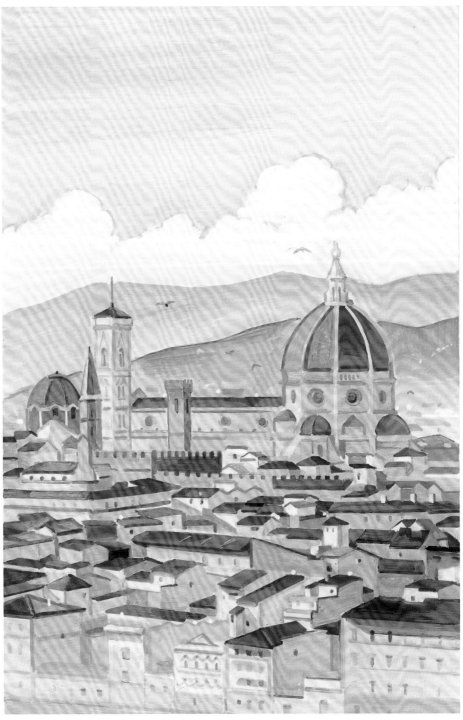

13. Fill the sky using a gradient from Light orange to Beige. Add birds and other small details with fine-tip White, Beige and Pink markers.

ZÜRICH AT TWILIGHT

When I think of Zürich, it's not any specific architectural wonder that comes to mind, but rather the enchantment of the Limmat river in the old town area that makes me remember Zürich fondly. The charm of this wonderful city resides in the beautiful historic buildings lining the riverbank, their images perfectly mirrored in the calm waters. After sunset, strolling along the river feels akin to stepping into an illustrated fairy tale. With a crescent moon hanging in the sky, the enchanting houses and their reflections create the perfect composition for an illustration.

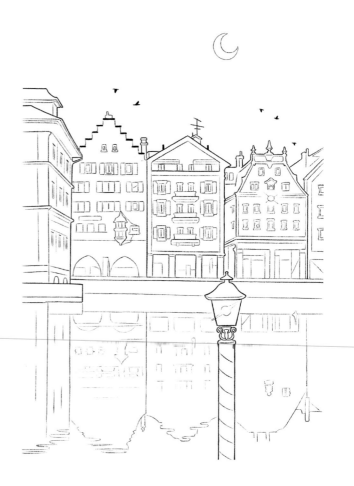

YOU WILL NEED

Markers

Extra-fine tip 0.7mm–1mm
Fine tip 0.9mm–1.3mm
Medium tip 1.8mm–2.5mm
Broad bullet tip 4.5mm–5.5mm
Broad chisel tip 5.5.mm–8mm

HB pencil
Eraser
Washi tape

Colors (Posca colors in roman, Molotow in italic)

| Lavender | Light pink | Light orange | Ivory | Coral pink | White | Beige | Apricot | *Powder pastel* | Dark brown |

| Light blue | Sky blue | Turquoise | Brown | Violet | Lilac | Pink |

1. For the left-hand building, blend from Lavender into Light pink, Light orange and Ivory. Use Light orange and Coral pink for the bottom.

2. Fill in the brightly lit area of the middle building with White and Ivory, then overlay Coral pink, blending into Light orange on top.

3. Use Beige, Apricot and *Powder pastel* for walls, and Dark brown for the roofs. Add lights with Ivory and White. Use Light pink for the bottom area in shadow.

4. Apply White near the buildings and the moon, then blend with a broad bullet-tip Light blue marker.

5. Add new paint to the existing Light blue, blending it smoothly into Sky blue and then Turquoise.

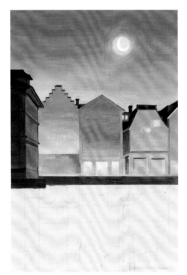

6. Work on the dark midground building using Coral pink, Brown, Violet and Dark brown.

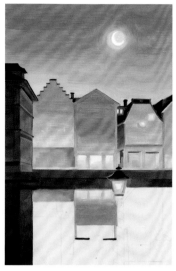

7. Draw the lamp with Light orange, Apricot, Brown and Dark brown. Draw the reflection in the water using colors based on the corresponding buildings.

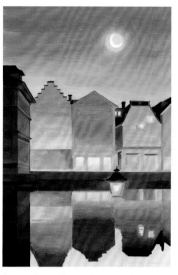

8. Darken the reflection by blending into Brown, Violet and Dark brown. Leave the reflection of the lamps as White and Ivory.

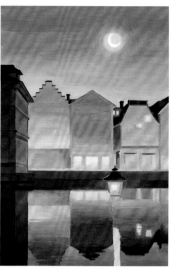

9. Use Light blue and Sky blue to depict the water mirroring the sky. Include streaks to denote water movement.

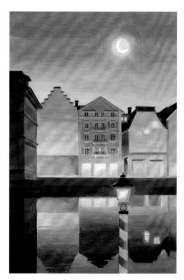

10. Add stripes to the lamp post using *Powder pastel*, Lavender and Lilac. Use extra-fine-tip Violet, Pink and Light pink to add window details to the center building.

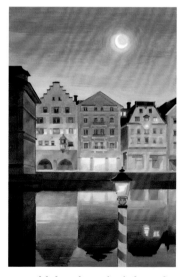

11. Add details to the left- and right-hand buildings with extra-fine-tip White, Light pink and Brown, and fine-tip Coral pink, Lavender and Dark brown.

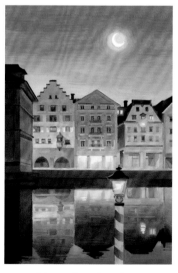

12. Add window details to the reflection in Brown, Pink and Violet with blurred edges and less contrast.

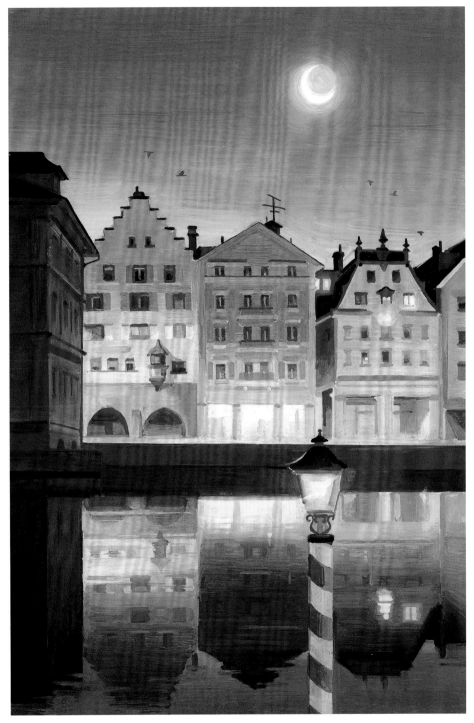

15. To complete the drawing, add details such as chimneys and antennas to the buildings, and add small birds flying sideways to make the scene more lively.

ACKNOWLEDGMENTS

When I was young, I might have found it hard to imagine that one day my name would appear on the cover of an art teaching book. Although I've always loved drawing since I was little, there wasn't much of an artistic atmosphere at home, and no one in my family expected me to pursue art. Even until high school, I thought I would study accounting. But my love for drawing has never wavered since I can remember. From oil pastel drawings in kindergarten, through drawing manga covers in elementary school and acrylic paintings in high school, to studying animation in college, and then slowly developing my original style, I've persisted with drawing all along, leading me to the day that I drew the illustrations in this tutorial book.

Perhaps what I am most thankful for is discovering the existence of acrylic paint markers as an art medium. They are simply perfect for me. Over the past three years, I've been using them to draw continuously, allowing more people to see my work, and even leading to a publishing house contacting me to create this tutorial book. I am grateful to Octopus Publishing, Ellie, Ellen and the rest of the team for recognizing my work, giving me so much trust and encouragement, and allowing me to create this book with confidence. In the limited time I was given to create this book, I tried my best to cover as many techniques and step-by-step tutorials as I could. Due to the format of the book, I wasn't able to explain all the steps in detail. If readers encounter any problems or questions, feel free to reach out to me on Instagram, as I'm always happy to help.

I also want to thank my family, especially my mother, for supporting every decision I make as a person and an artist. And I'm grateful to my husband, George, because ever since meeting him I've been able to draw every day with a sense of security and love. Thanks to all my friends for listening to me complain about my back pain and late nights. And thanks to everyone who has seen my art online, supported me, and shown appreciation for my work. Your support keeps me going, and I hope to keep drawing forever.